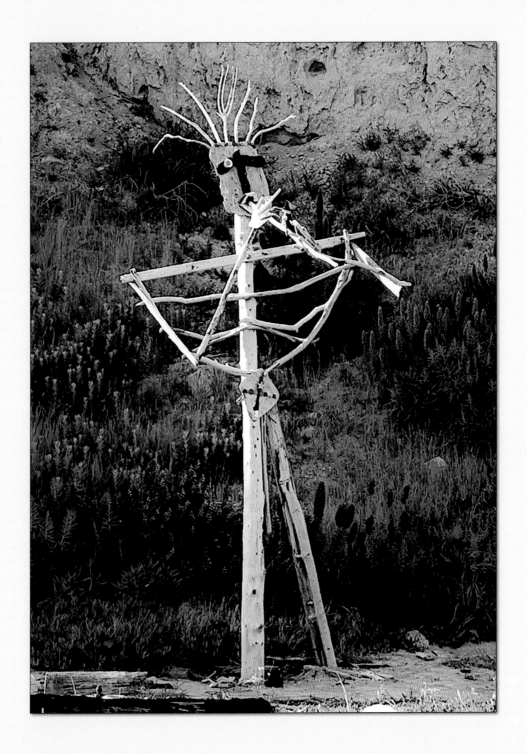

LIBRARY OF CONGRESS CATALOGING-IN-PUBLICATION DATA

NAMES: KAHN, LLOYD, 1935- AUTHOR.

TITLE: DRIFTWOOD SHACKS : ANONYMOUS ARCHITECTURE ALONG THE CALIFORNIA COAST /
LLOYD KAHN.

DESCRIPTION: BOLINAS, CA : SHELTER PUBLICATIONS, INC., [2018]

IDENTIFIERS: LCCN 2017054475 |

ISBN 9780936070803 (HARDCOVER) | ISBN 9780936070711 (PAPERBACK) |

ISBN 9780936070759 (EPUB) | ISBN 9780936070766 (KINDLE)

SUBJECTS: LCSH: SMALL HOUSES — CALIFORNIA — PACIFIC COAST — PICTORIAL WORKS. |

SHEDS — CALIFORNIA — PACIFIC COAST — PICTORIAL WORKS. |

VERNACULAR ARCHITECTURE — CALIFORNIA — PACIFIC COAST.

CLASSIFICATION: LCC NA7235.C2 K34 2017 | DDC 728/.9 — DC23

LC RECORD AVAILABLE AT HTTPS://LCCN.LOC.GOV/2017054475

5 4 3 2 1 — 20 19
(LOWEST DIGITS INDICATE NUMBER AND YEAR OF LATEST PRINTING.)

PRINTED IN CHINA BY MIDAS PRINTING INTERNATIONAL LIMITED

PAGE i, BEACH SCULPTURE BY BOB DEMMERLE
BEACH SCULPTURE AT RIGHT BY MAC MURPHY

SHELTER PUBLICATIONS, INC.
BOLINAS, CALIFORNIA, USA

NOTE: 1% OF THE SALES OF THIS BOOK GO TO 1% FOR THE PLANET,
AN ORGANIZATION DEVOTED TO PROTECTING THE PLANET AND
RAISING AWARENESS OF OCEAN AND ENVIRONMENTAL ISSUES.

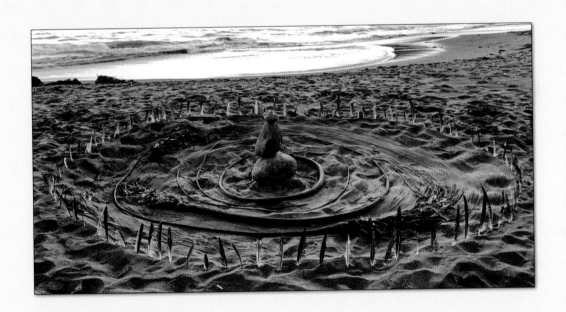

I'VE BEEN BEACHCOMBING A LOT IN RECENT YEARS, SINCE I QUIT COMPETITIVE RUNNING. IT'S ENDLESSLY FASCINATING. EVERY BEACH DAY IS DIFFERENT. YOU NEVER KNOW WHAT IT'LL BE LIKE UNTIL YOU GET THERE.

SOMETIMES THE WIND IS BLOWING, AND IT'S COLD AND UNCOMFORTABLE. BUT OTHER TIMES, EVERYTHING LINES UP — TIDE, SWELL, WIND, SUN, AND IT'S BEAUTIFUL. THE AIR IS FRESH AND SWEET-SMELLING. THE NEGATIVE IONS BOOST YOUR *CHI*. THERE'S NO NEED FOR CLOTHES ON REMOTE BEACHES.

IT'S ALWAYS A DELIGHT TO COME UPON SOMETHING BUILT OUT OF DRIFTWOOD. THEY'RE ANONYMOUS: I DON'T KNOW WHO BUILT ANY OF THESE. THEY'RE EPHEMERAL: NONE OF THEM LAST VERY LONG — VICTIMS OF WINTER STORMS, HIGH TIDES, OR BIG SURF. THEY'RE DESIGNED BY MATERIALS AVAILABLE: WHATEVER HAPPENS TO BE LAYING ON THE BEACH. AND ALMOST ALL OF THEM ARE BUILT WITHOUT NAILS. (ALL OF THESE STRUCTURES WERE GONE BY THE TIME THIS BOOK WAS PRINTED.)

EVERY SO OFTEN I CAMP ON THE BEACH, SLEEPING INSIDE OR ALONGSIDE THESE SHACKS — COOKING DINNER OVER A FIRE, STAR-GAZING, WATCHING SUNSETS AND SUNRISES.

THESE PHOTOS WERE TAKEN OVER MANY YEARS OF BEACHCOMBING. TO SHOOT THE LAST PHOTOS, I TOOK A THREE-DAY BACKPACKING TRIP ALONG THE LOST COAST IN HUMBOLDT COUNTY, CALIFORNIA *(SEE PAGES 124-147)*, AND HAD THE ADVENTURE OF A LIFETIME.

YOU'LL NOTICE THAT IN ADDITION TO SHACKS, THERE ARE PHOTOS OF WAVES, SURFERS, SEASHELLS, BIRDS, SEALS, SEAWEED, BONES, SCULPTURES, AND SUNSETS: AN "...EMBARRASSMENT OF RICHES."

*** * ***

THIS BOOK IS FOR BEACHCOMBERS EVERYWHERE. WE'RE ALL ALIKE: WHATEVER COUNTRY WE LIVE IN, WHATEVER THE BODY OF WATER, WE ALL SHARE A DEEP LOVE FOR THE OCEAN AND ITS SURROUNDINGS.

*** * ***

"OUR MEMORIES OF THE OCEAN WILL LINGER ON,
LONG AFTER OUR FOOTPRINTS IN THE SAND ARE GONE."
-ANONYMOUS

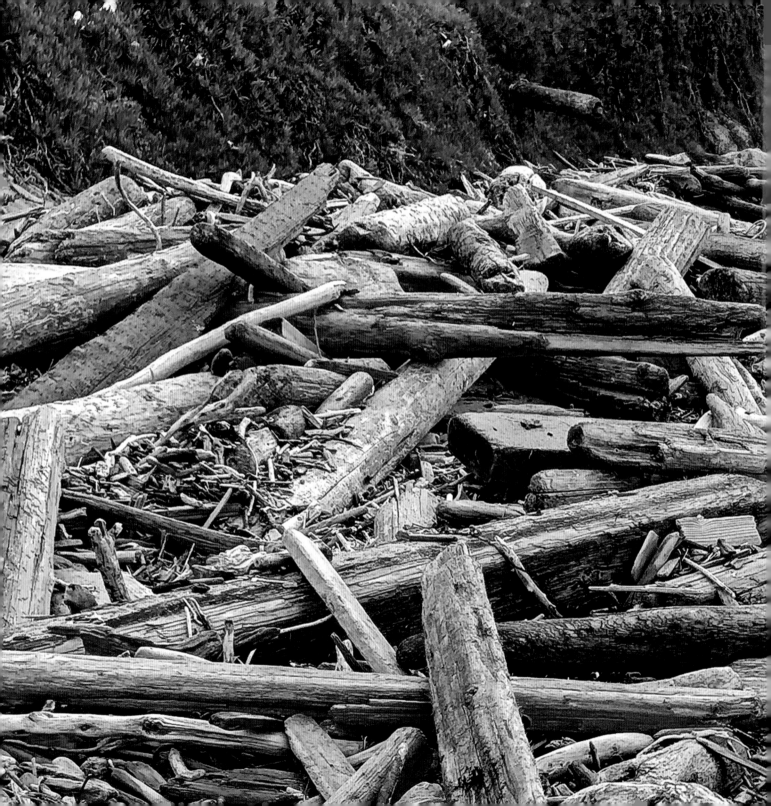

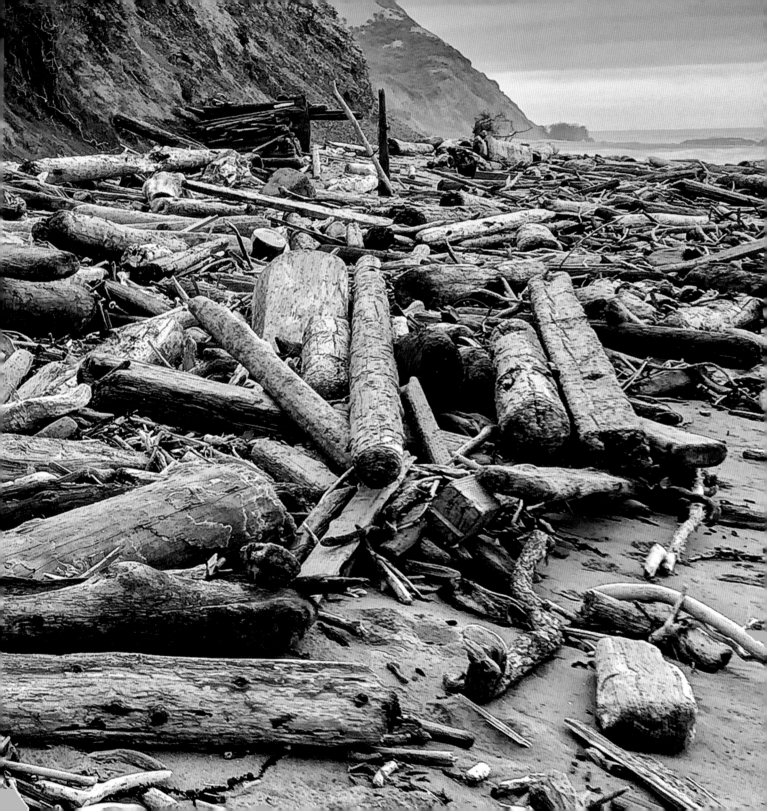

GUALALA POINT REGIONAL PARK

4

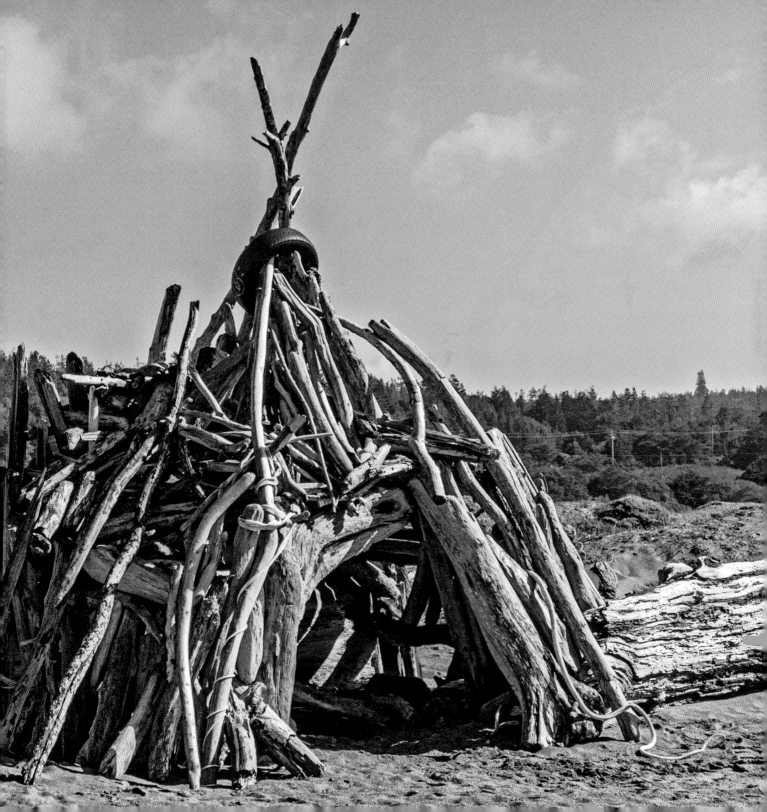

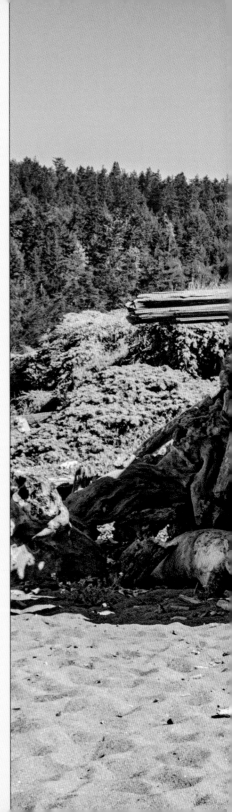

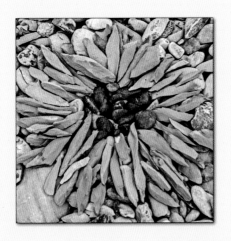

GUALALA POINT REGIONAL PARK

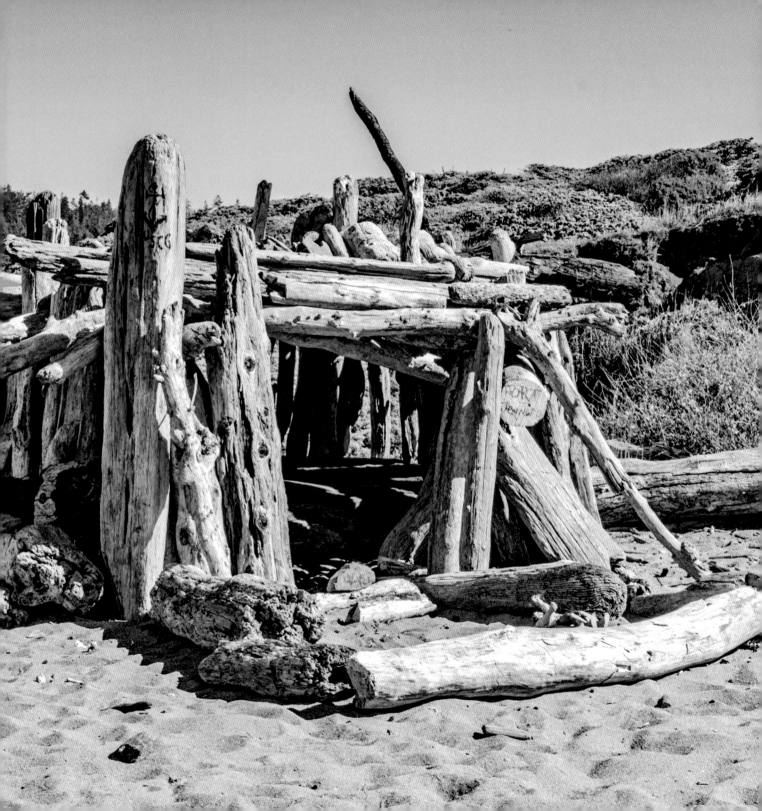

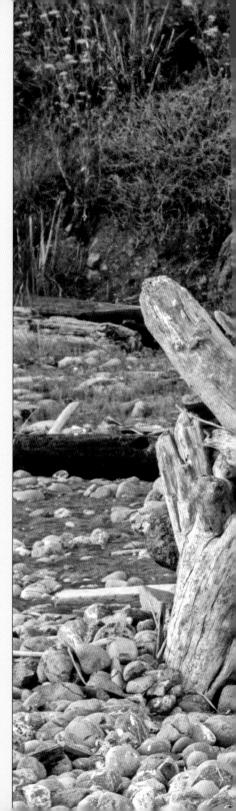

STEEP RAVINE BEACH, MARIN COUNTY

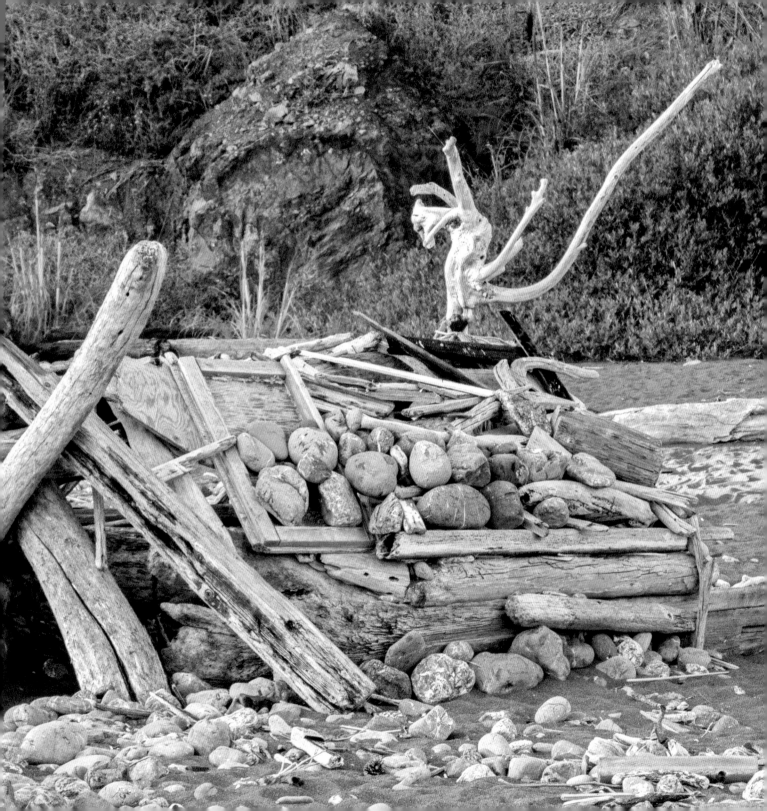

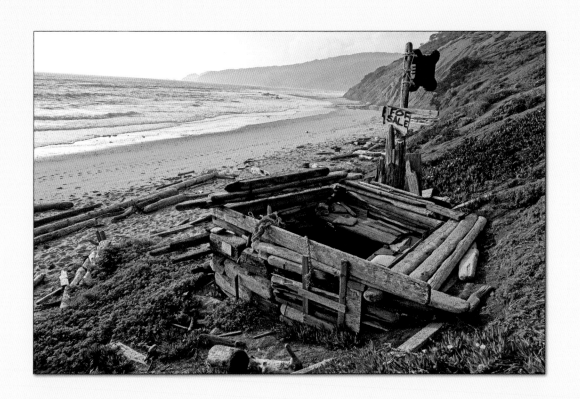

MARIN COUNTY

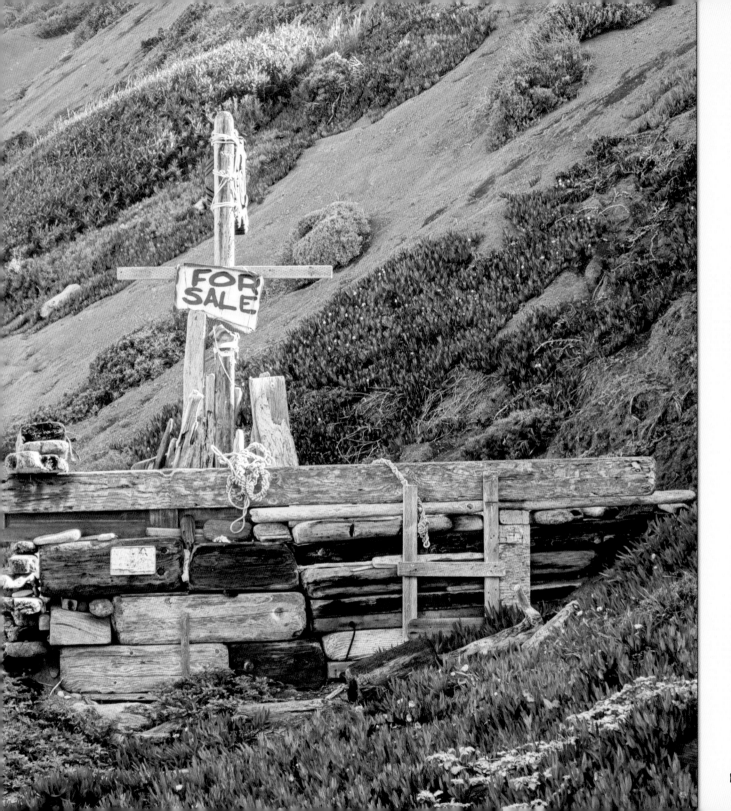

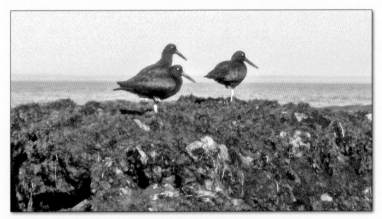

BLACK OYSTERCATCHERS

MARIN COUNTY

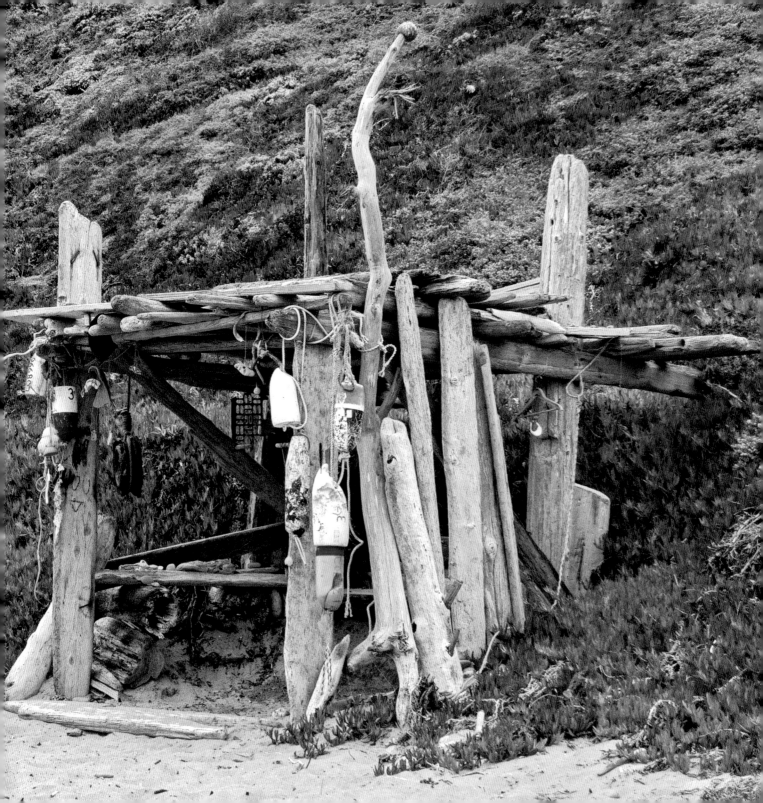

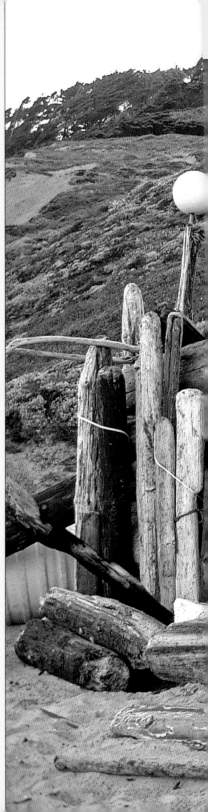

MARIN COUNTY

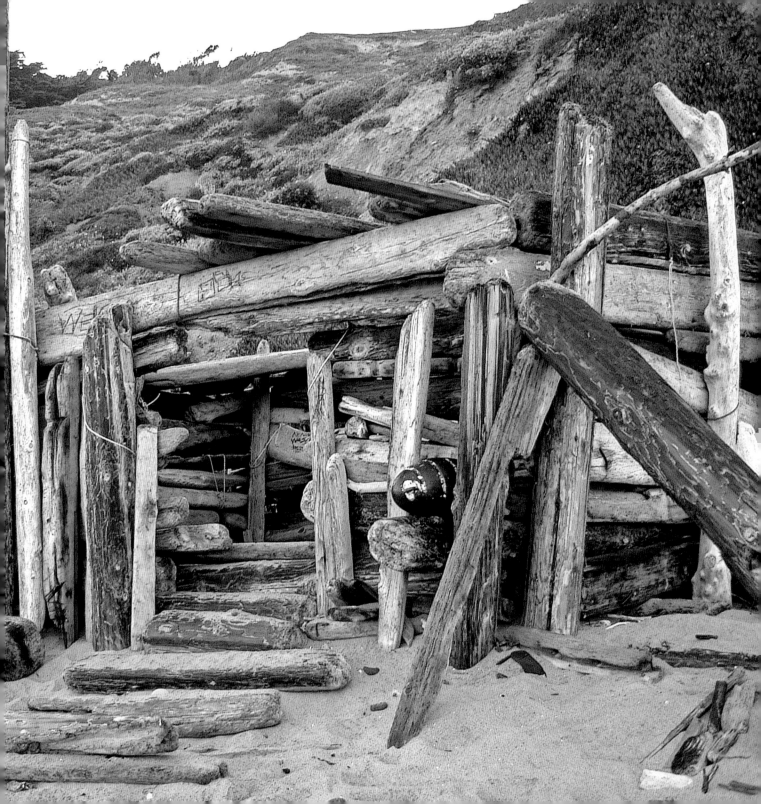

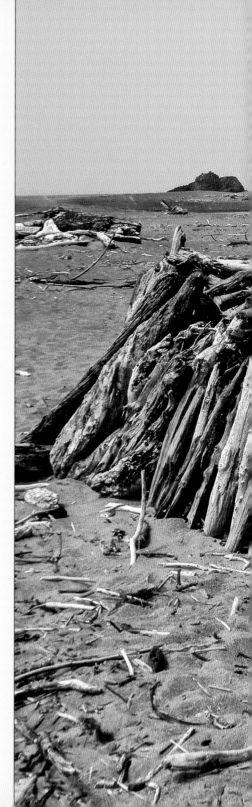

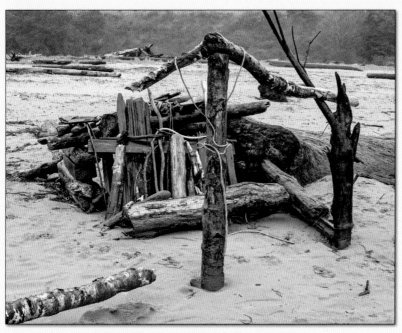

BIG RIVER BEACH, SOUTH OF MENDOCINO

NAVARRO BEACH, MENDOCINO COUNTY

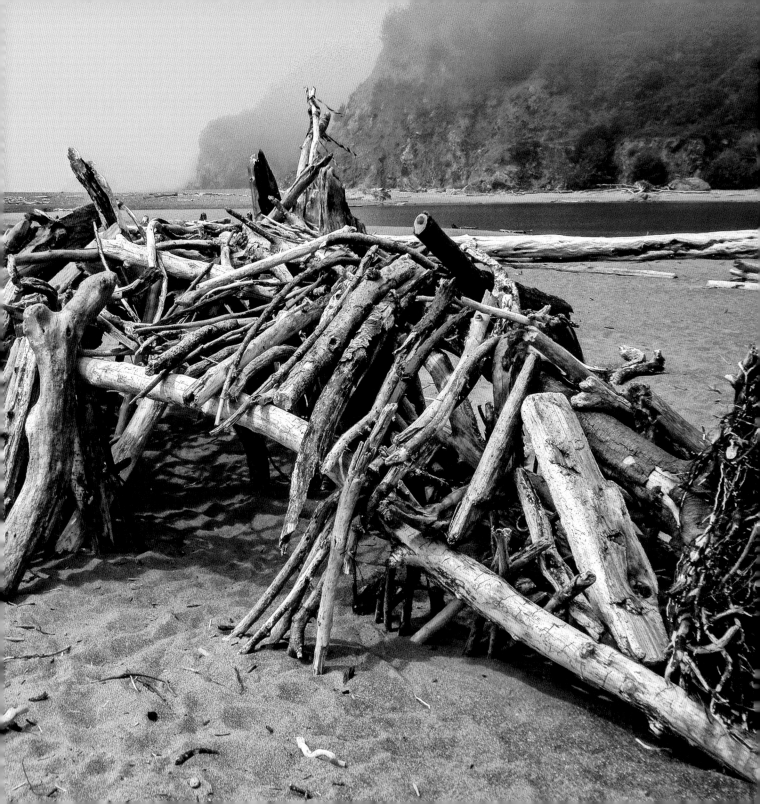

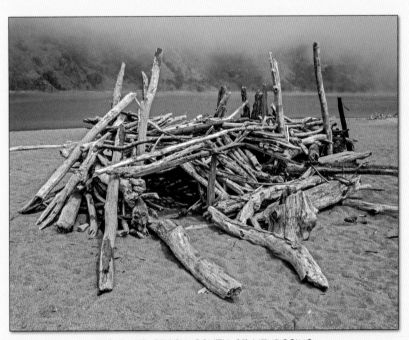

BIG RIVER BEACH, SOUTH OF MENDOCINO

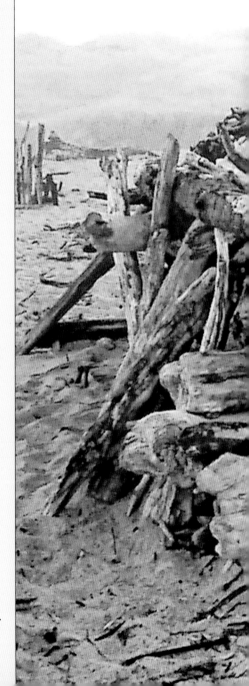

NAVARRO BEACH, MENDOCINO COUNTY

18

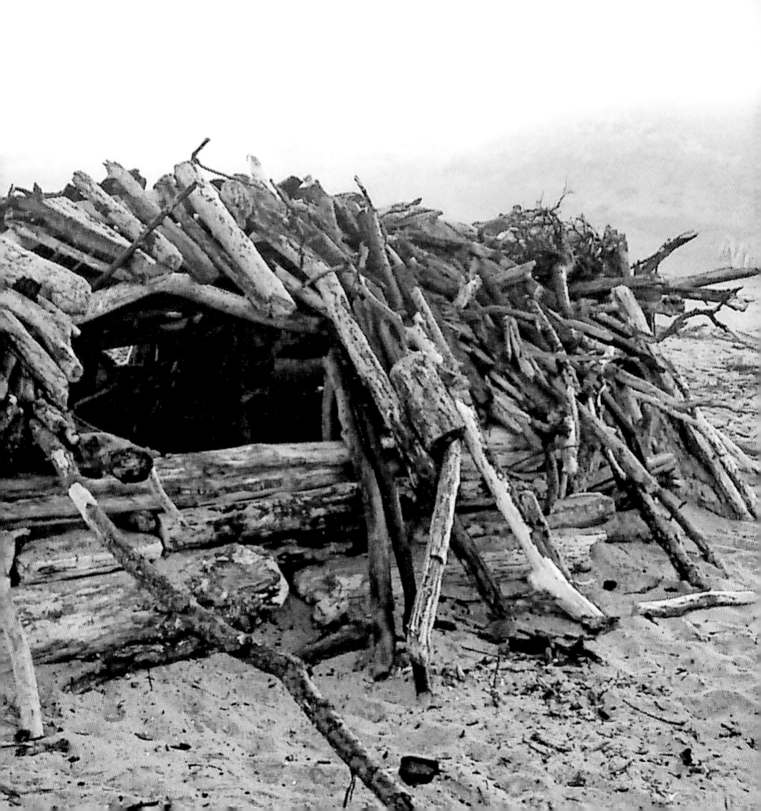

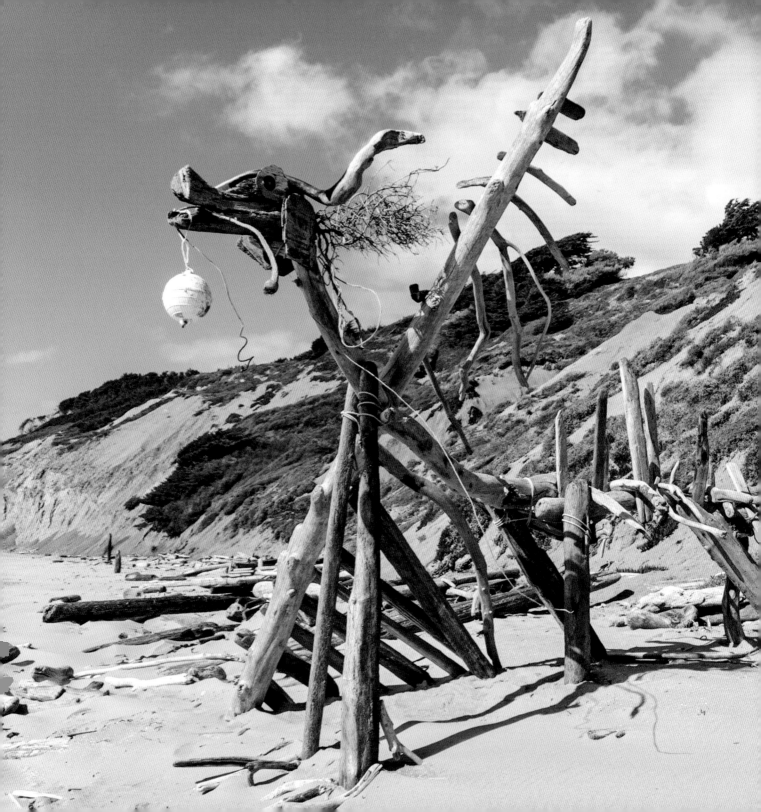

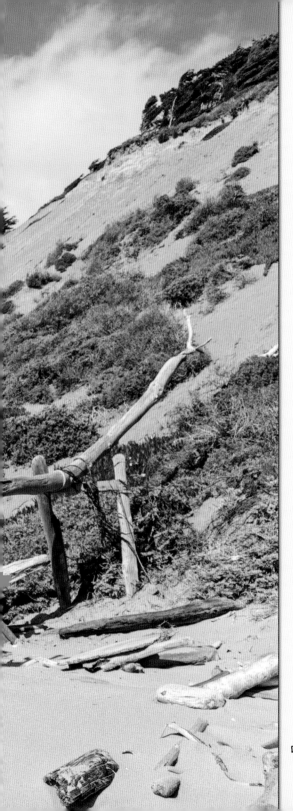

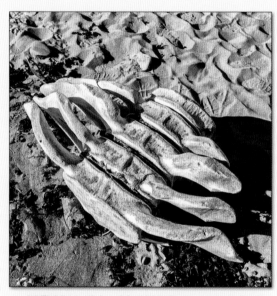

VERTEBRAE FROM 79-FOOT BLUE WHALE THAT
WASHED UP ON AGATE BEACH, MARIN COUNTY
IN MAY, 2017

DRAGON BY BOB DEMMERLE

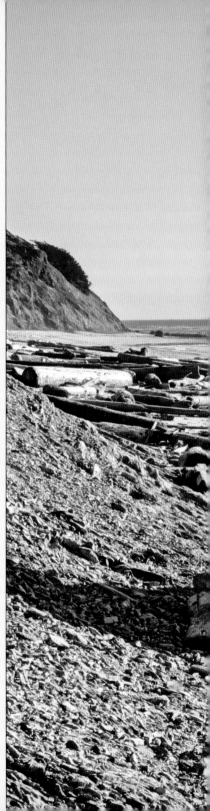

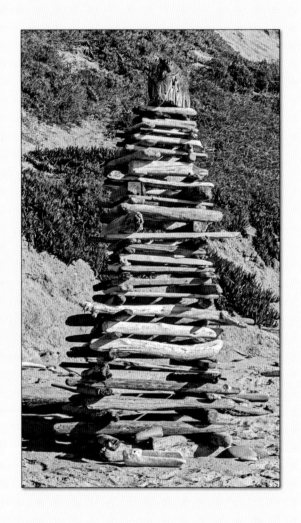

MARIN COUNTY

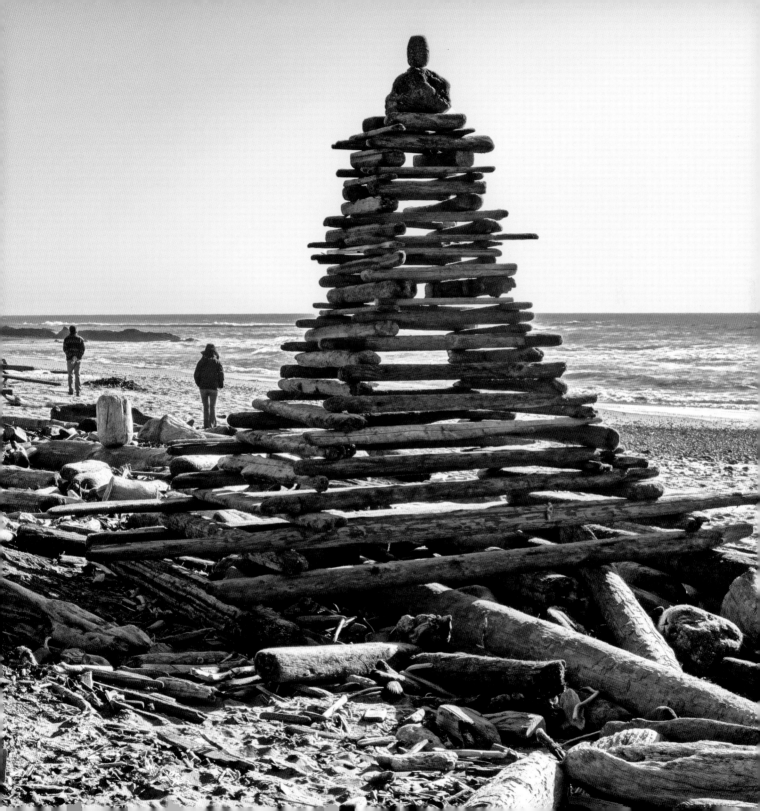

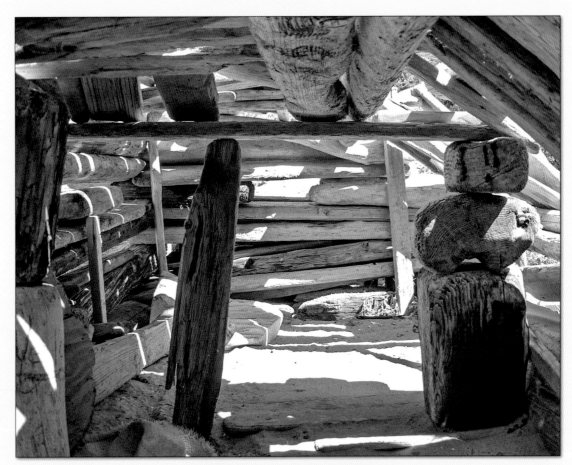

INSIDE OF STRUCTURE AT RIGHT

MARIN COUNTY

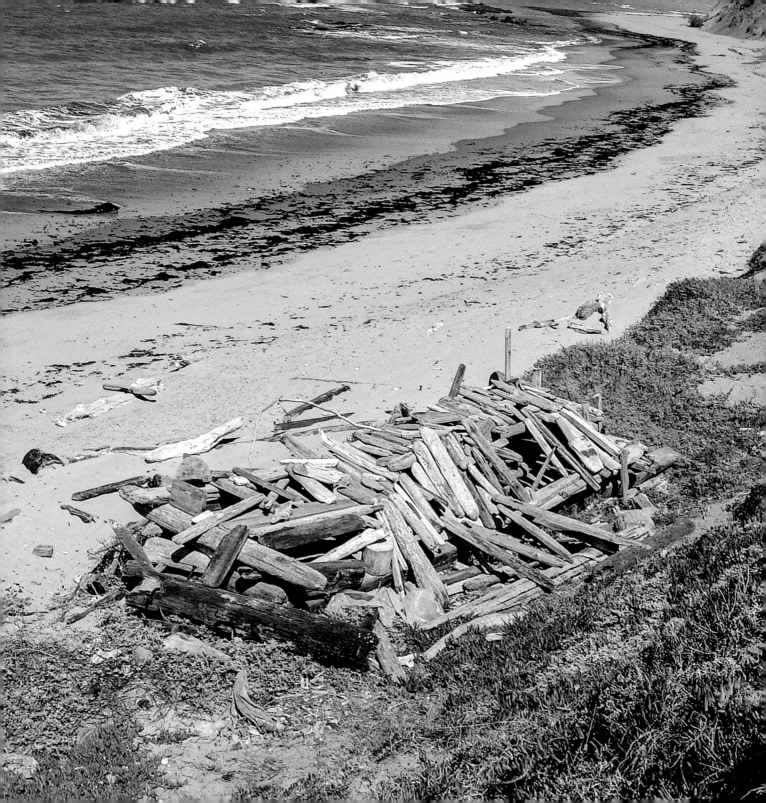

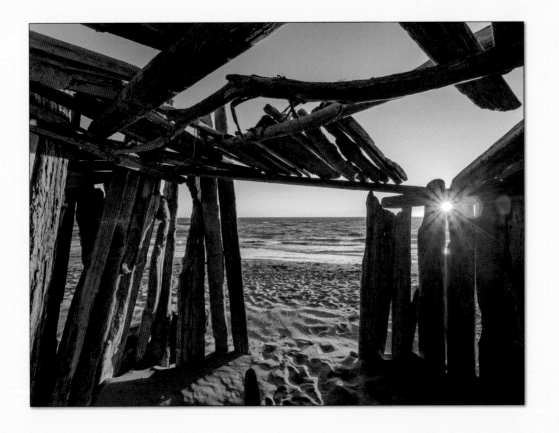

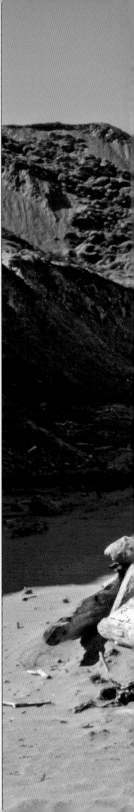

MARIN COUNTY

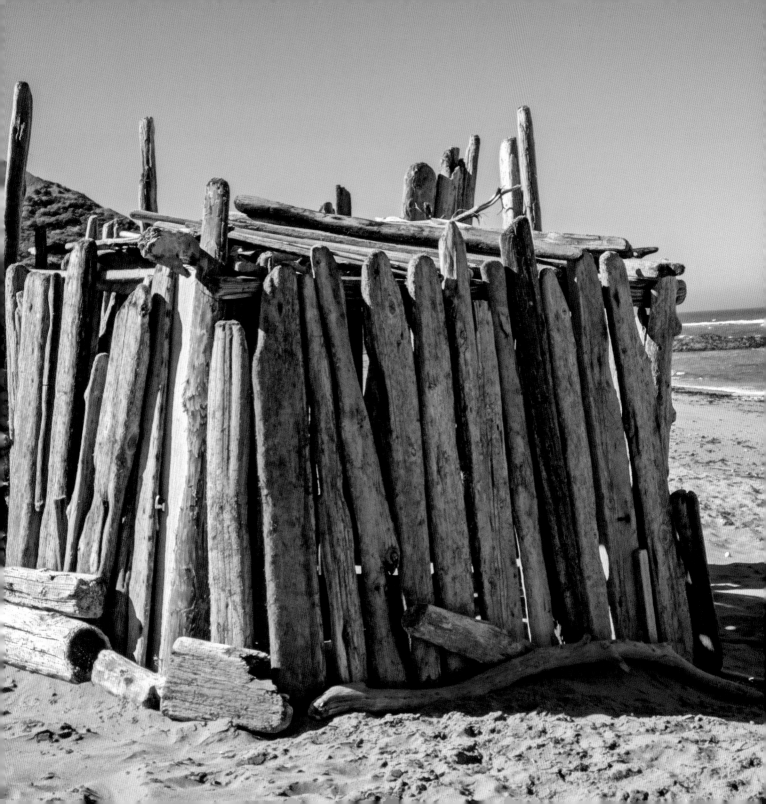

SEA CAVE, MARIN COUNTY

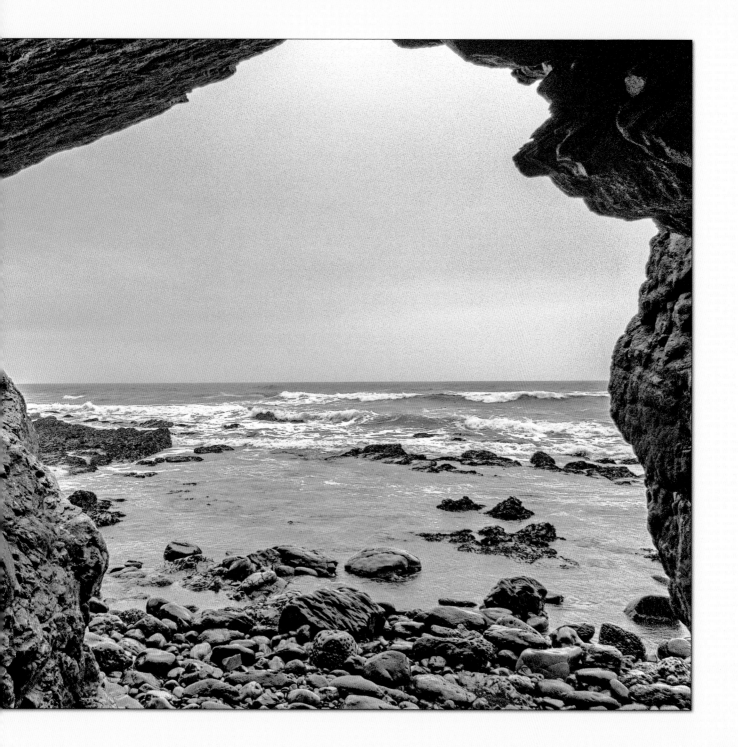

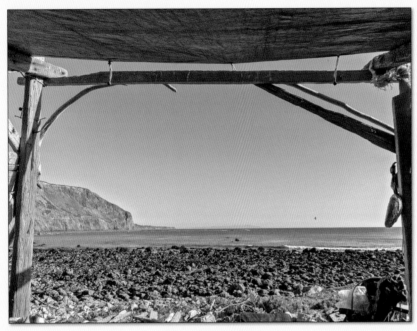

VIEW FROM INSIDE

MY SHACK. I USED SOME NAILS. IT WAS REMOTE, A TWO-HOUR HIKE TO GET THERE.
I CAMPED THERE A BUNCH OF TIMES AND NEVER SAW ANOTHER SOUL. IT LASTED
FOR A FEW YEARS BEFORE BEING DESTROYED IN A STORM. I'VE PROMISED
MYSELF THAT WHEN I FINISH THIS BOOK, I'LL CELEBRATE BY REBUILDING IT.

FOLLOWING TWO PAGES: MARIN COUNTY

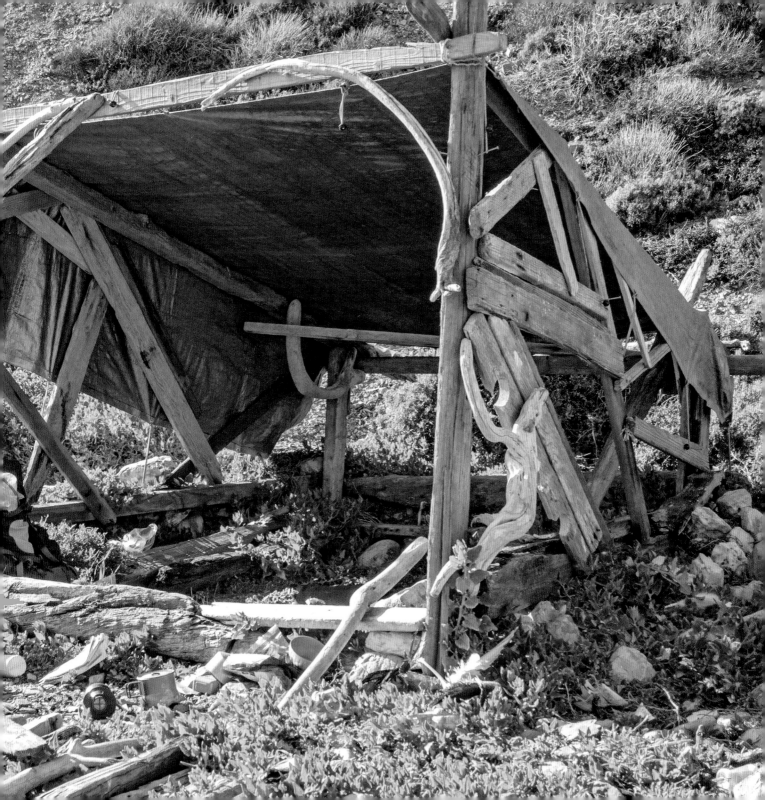

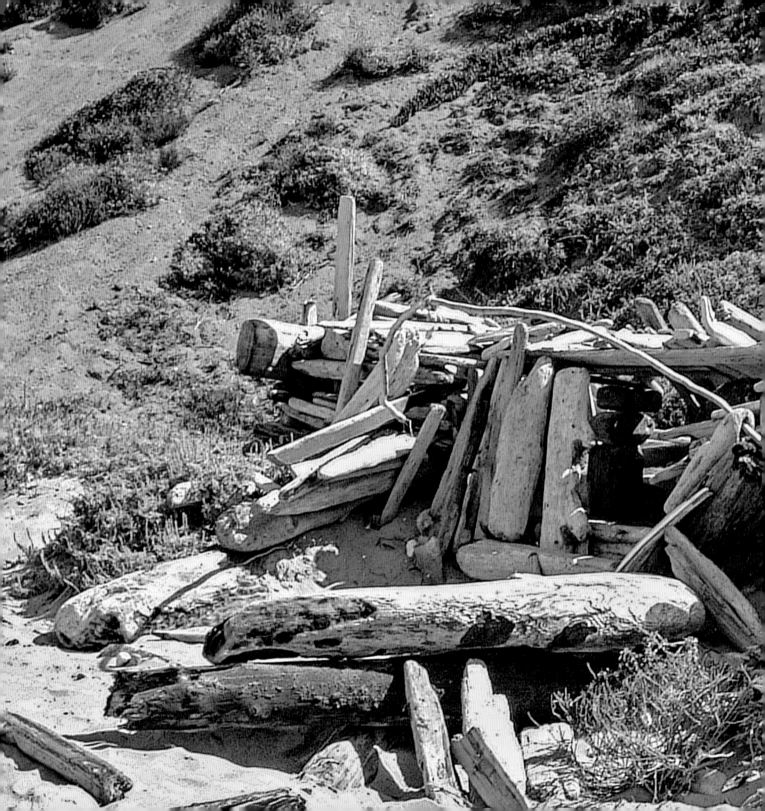

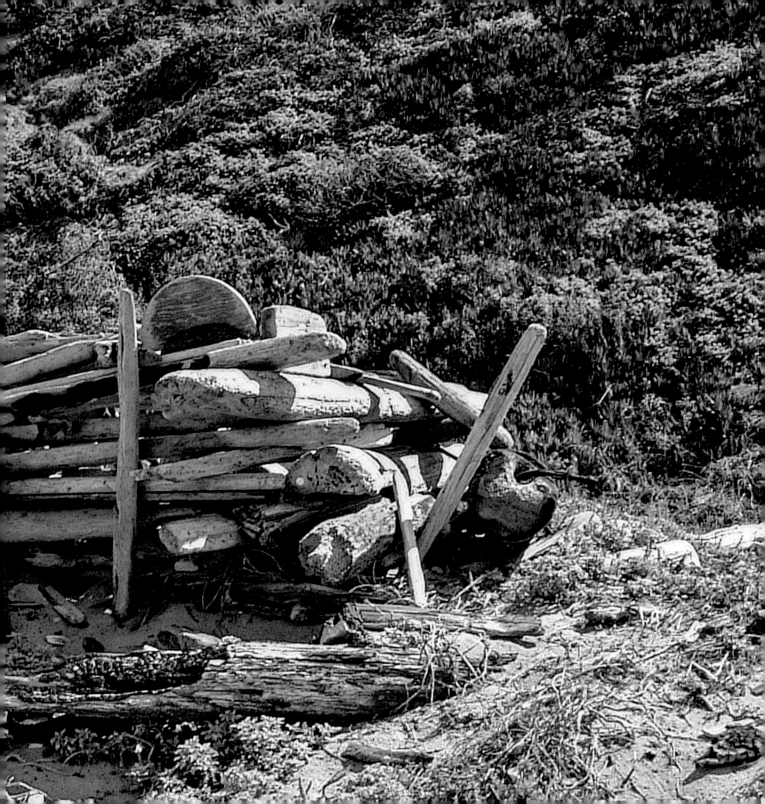

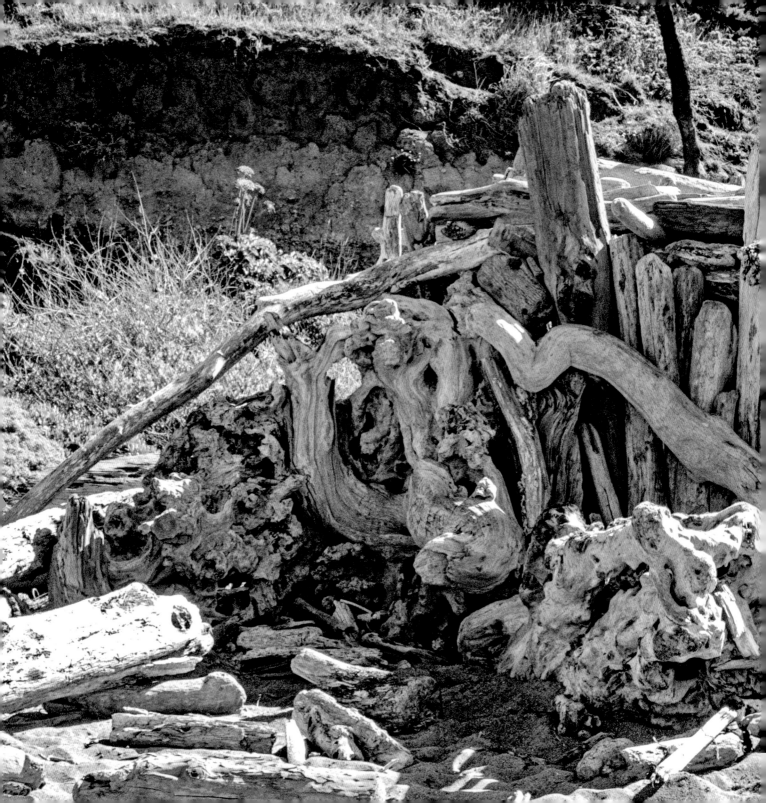

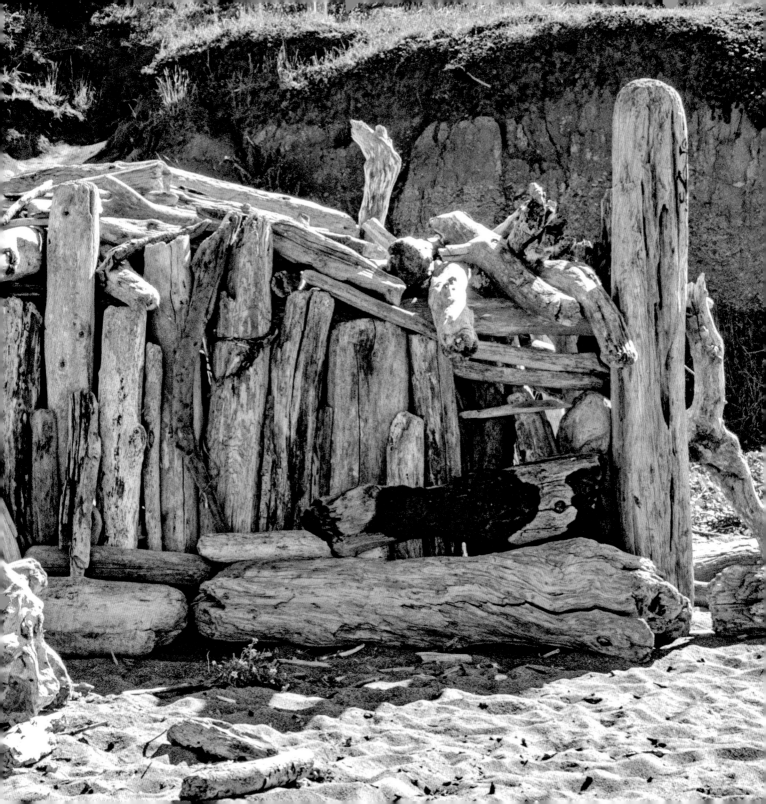

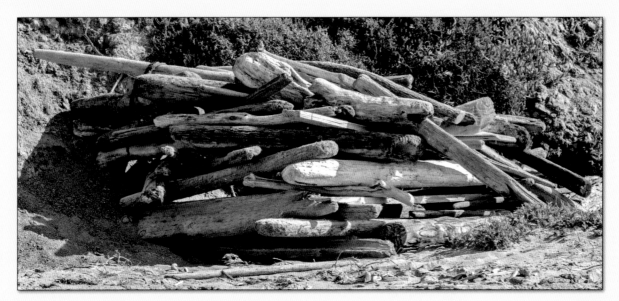

MARIN COUNTY

PREVIOUS TWO PAGES: GUALALA POINT REGIONAL PARK

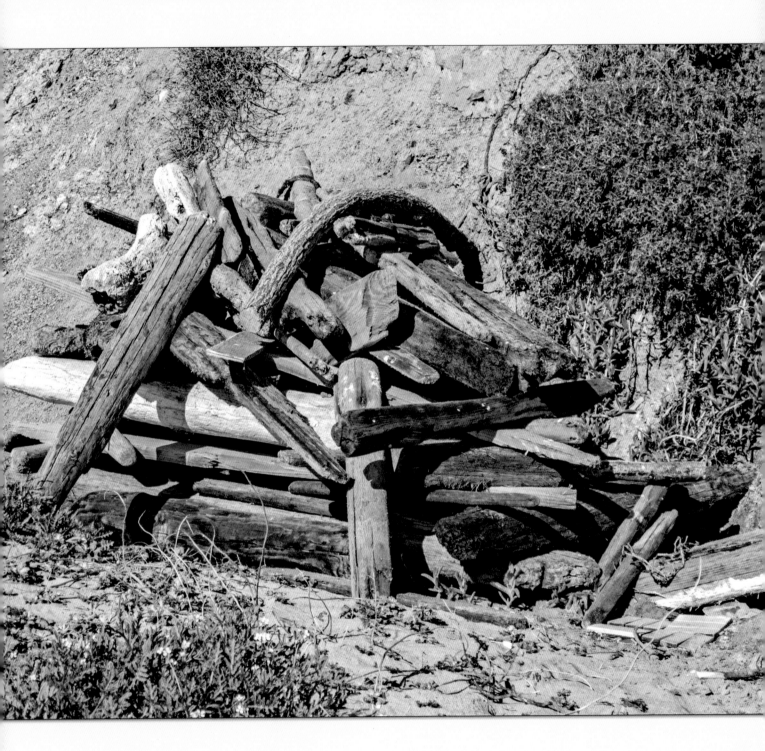

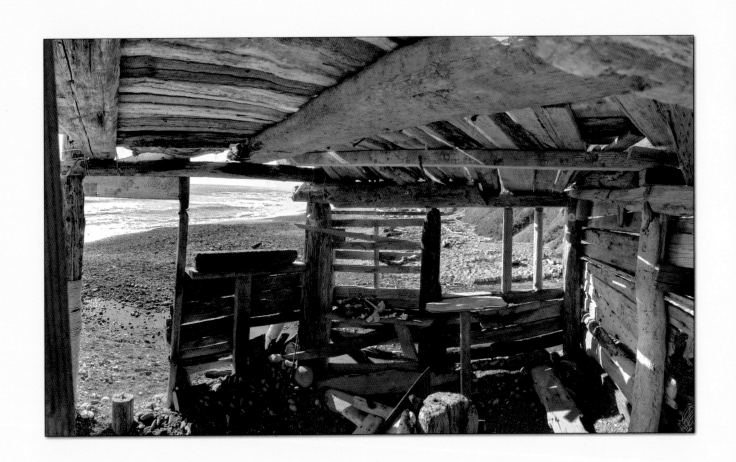

MARIN COUNTY

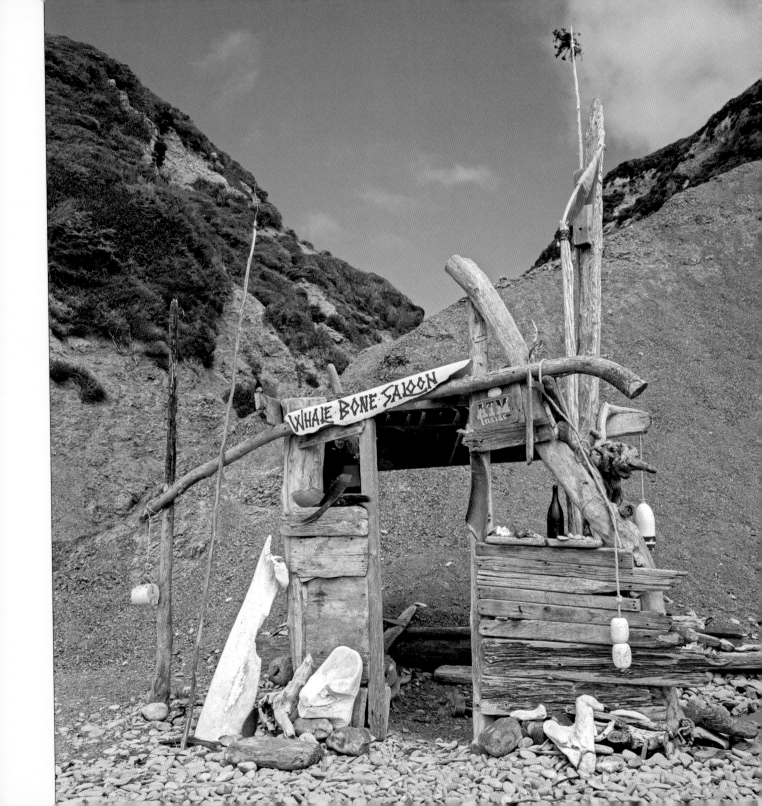

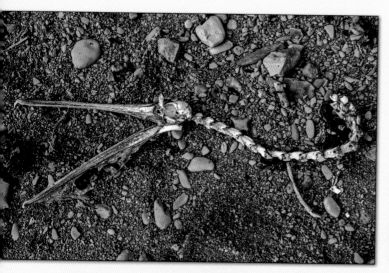

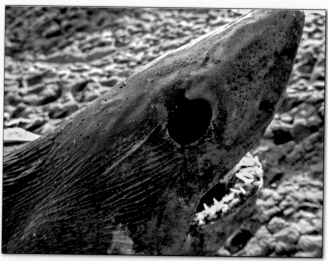

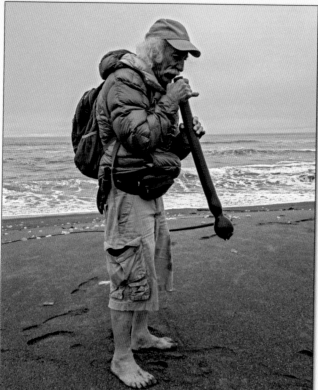

BULL KELP TRUMPET

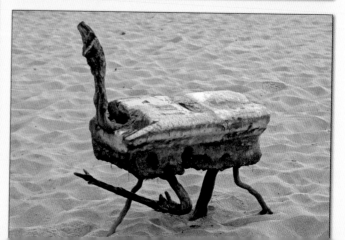

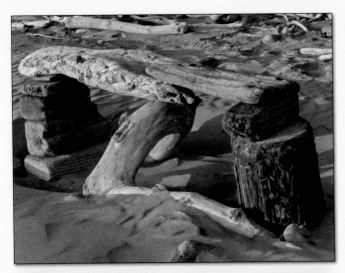

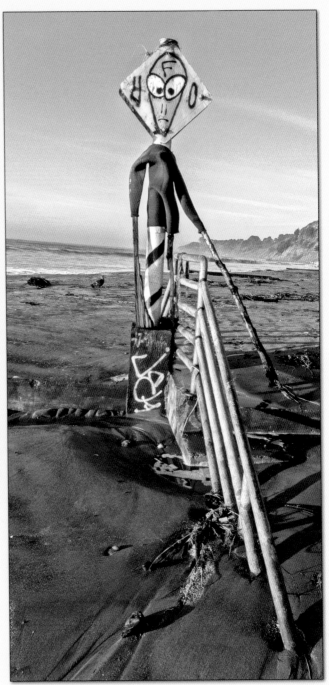

THE BOYS IN THE BAND, BY BOB DEMMERLE AND ZIM CAROSELLI

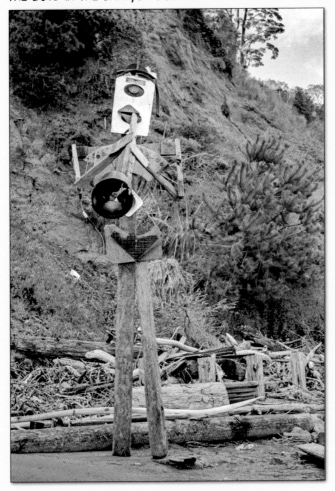
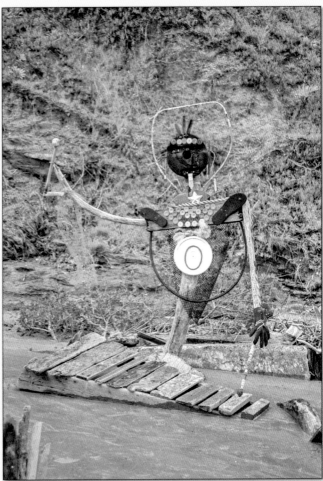

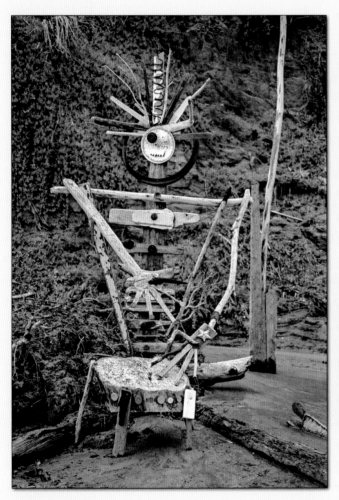

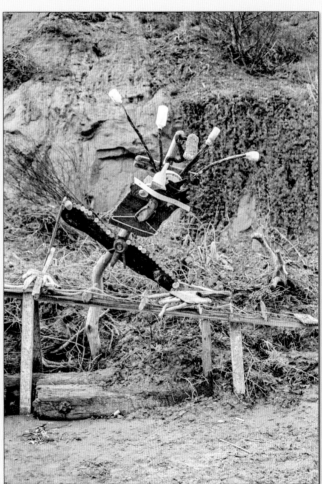

MARIN COUNTY

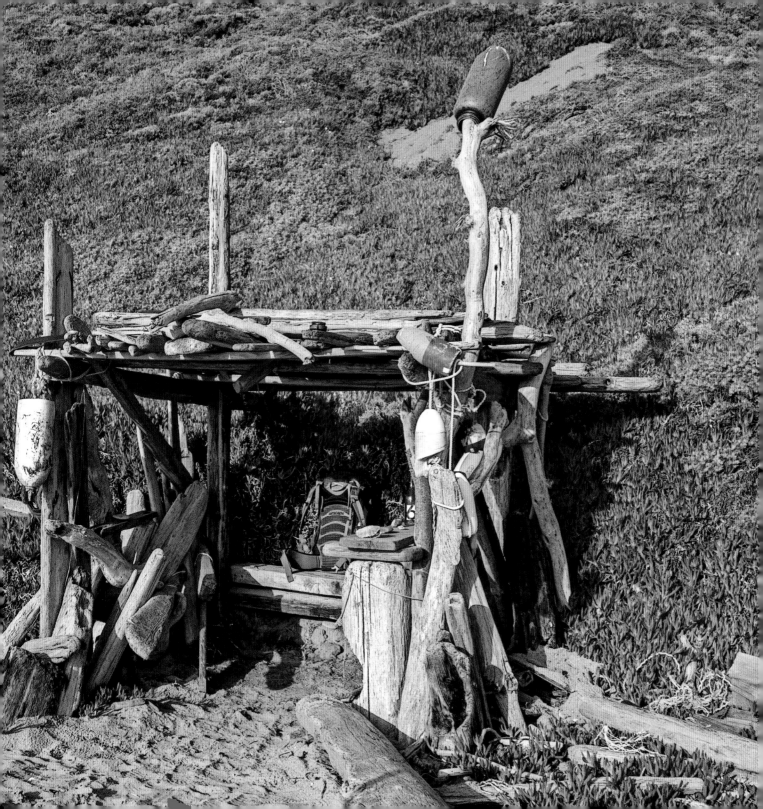

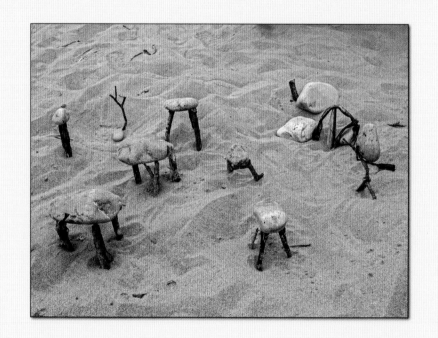

MARIN COUNTY

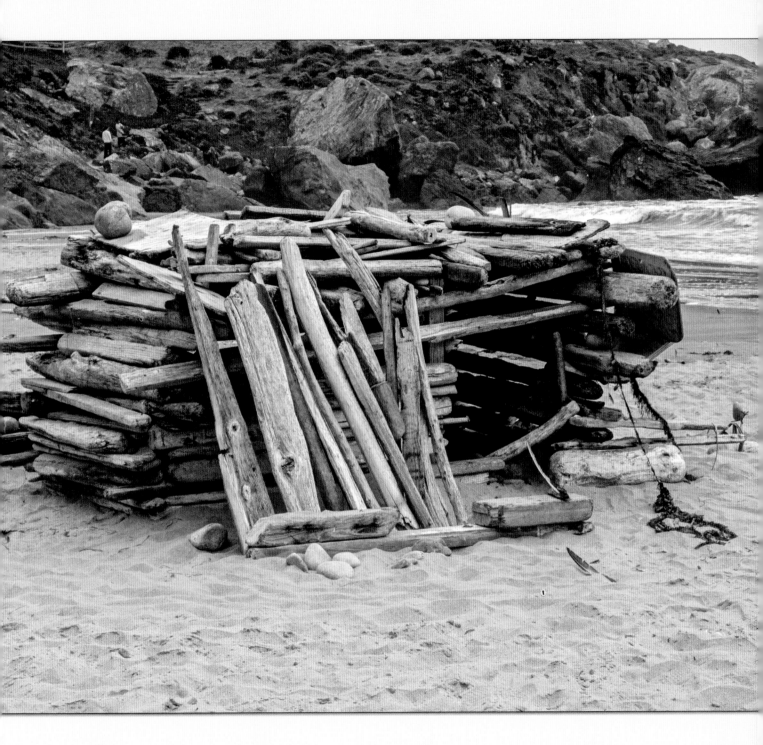

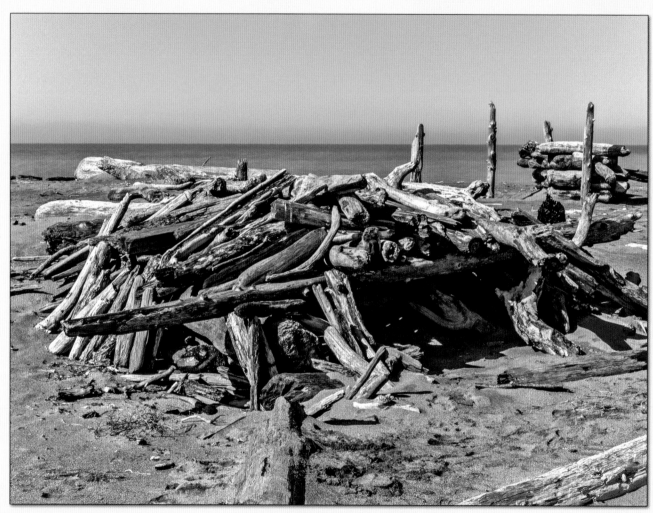

GUALALA POINT REGIONAL PARK

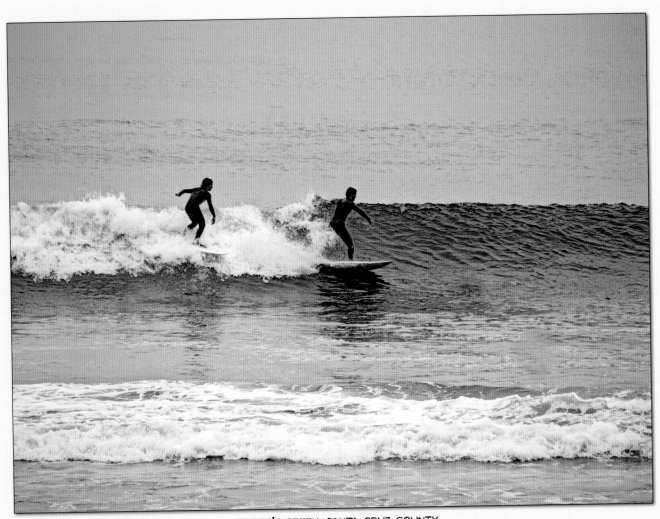

SCOTT'S CREEK, SANTA CRUZ COUNTY

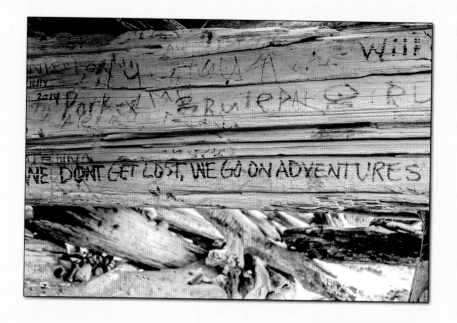

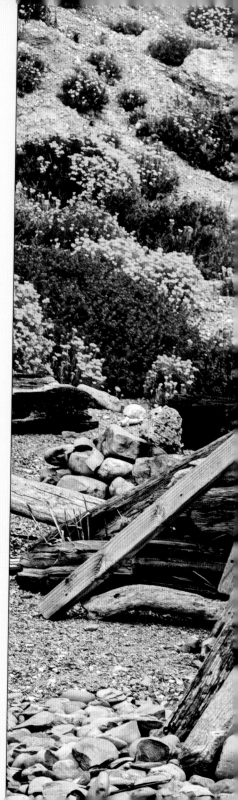

MARIN COUNTY

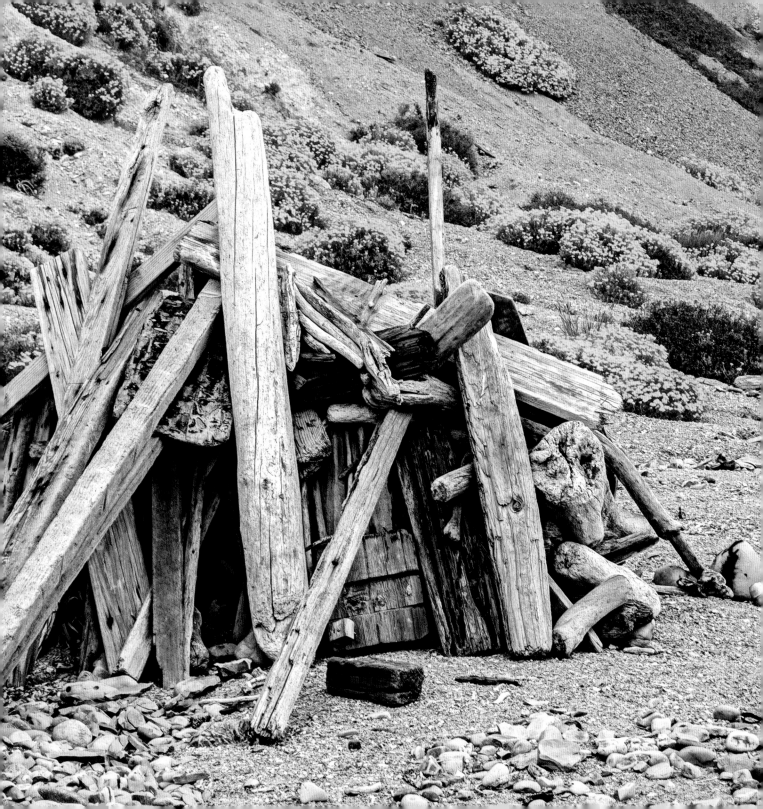

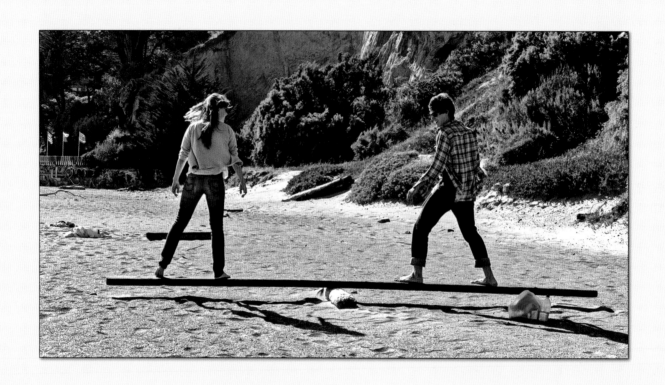

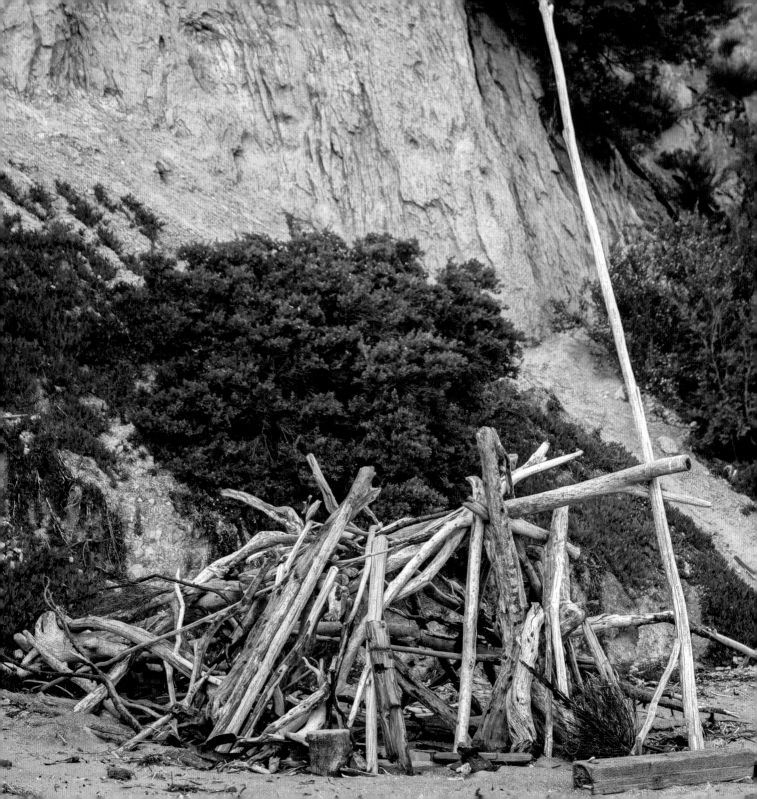

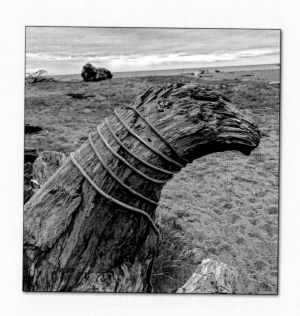

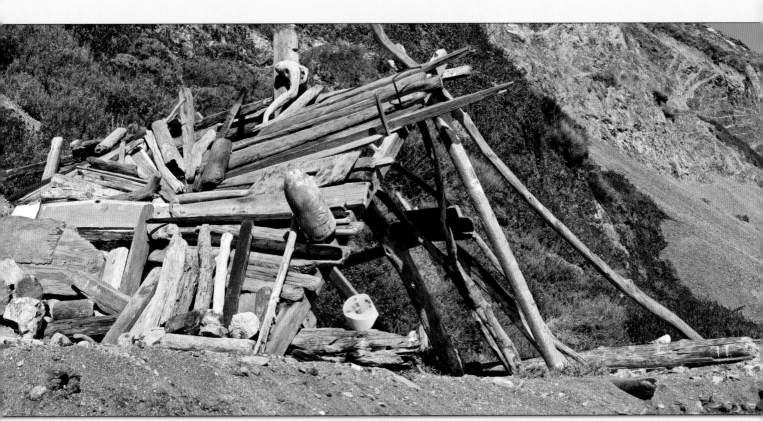

MARIN COUNTY

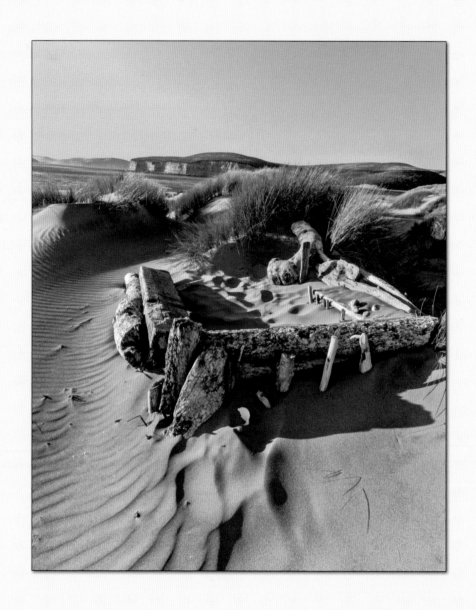

LIMANTOUR BEACH

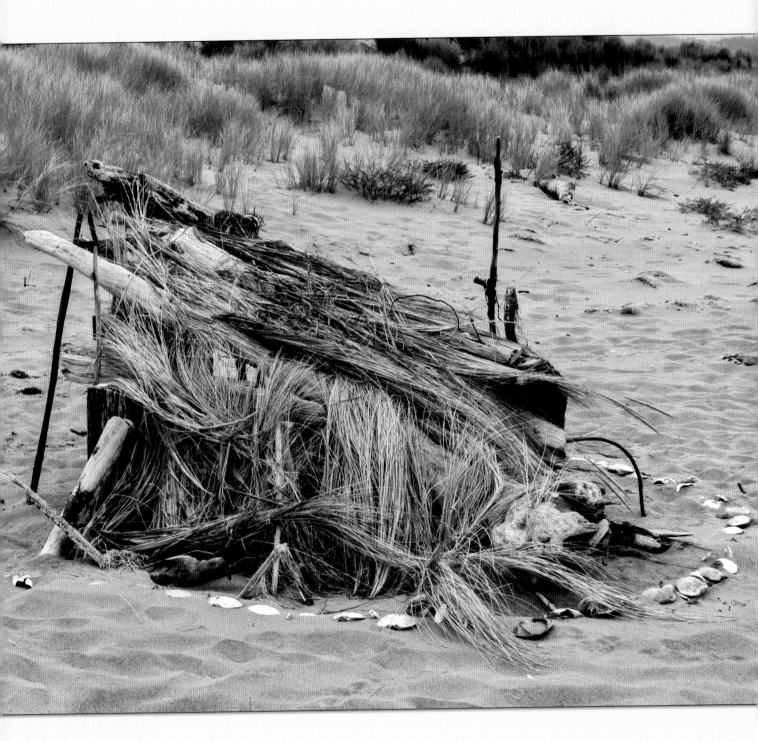

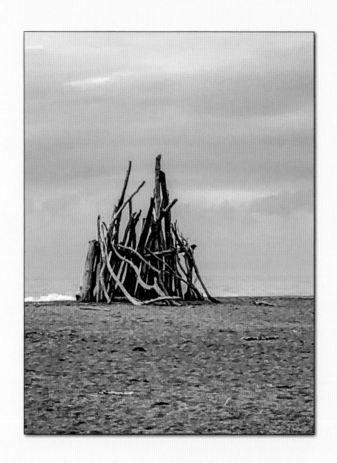

NORTH SALMON CREEK BEACH

FOLLOWING TWO PAGES: SOUTH SALMON CREEK BEACH

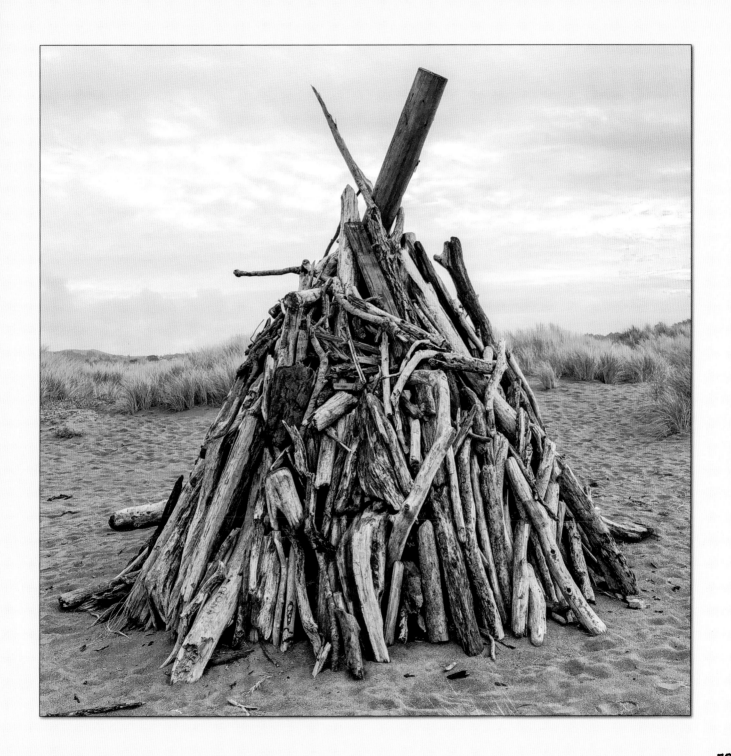

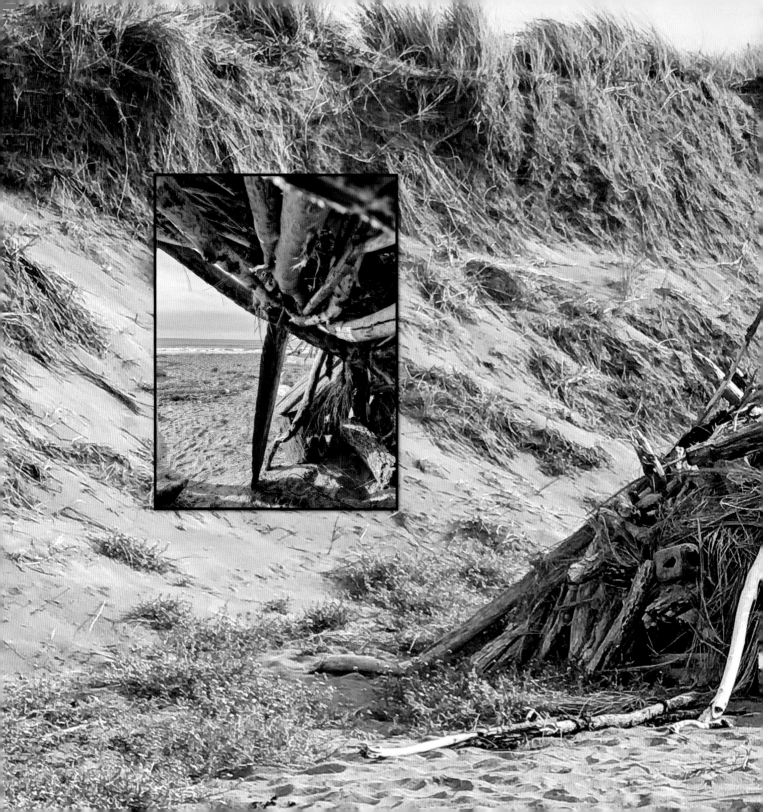

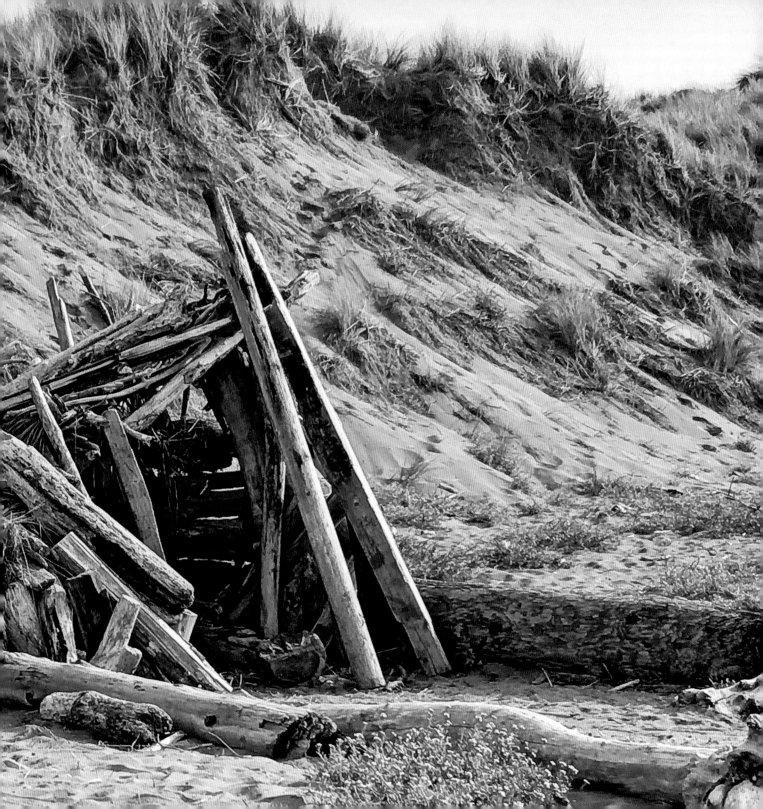

NORTH SALMON CREEK BEACH

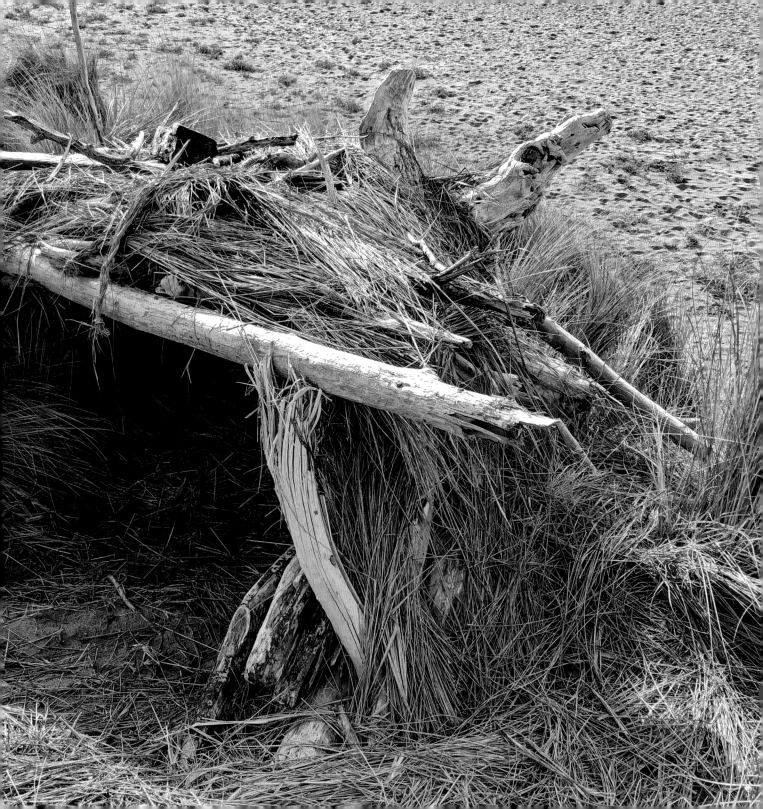

SOUTH SALMON CREEK BEACH

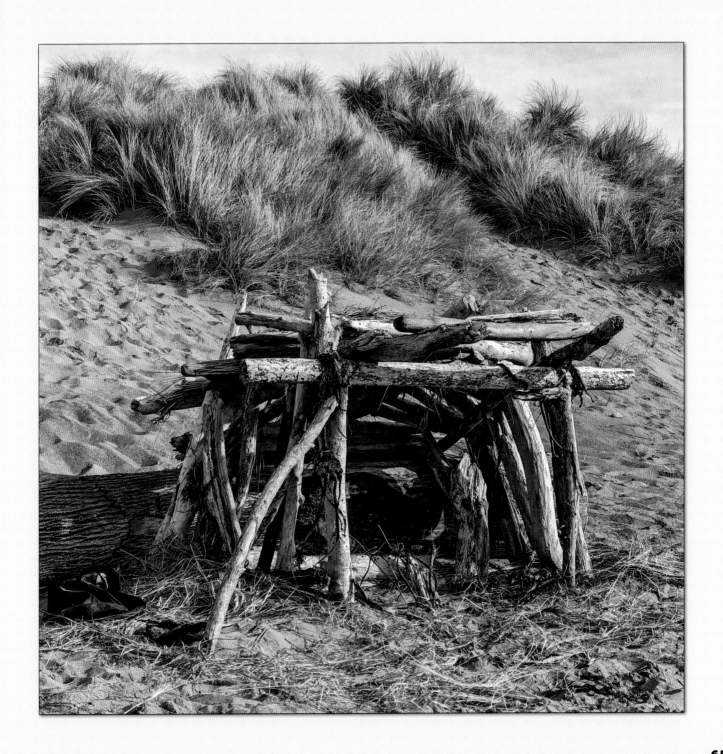

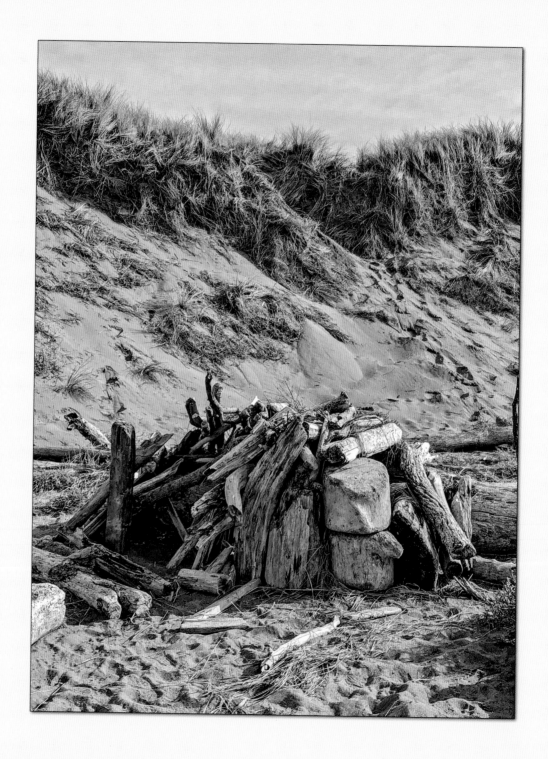

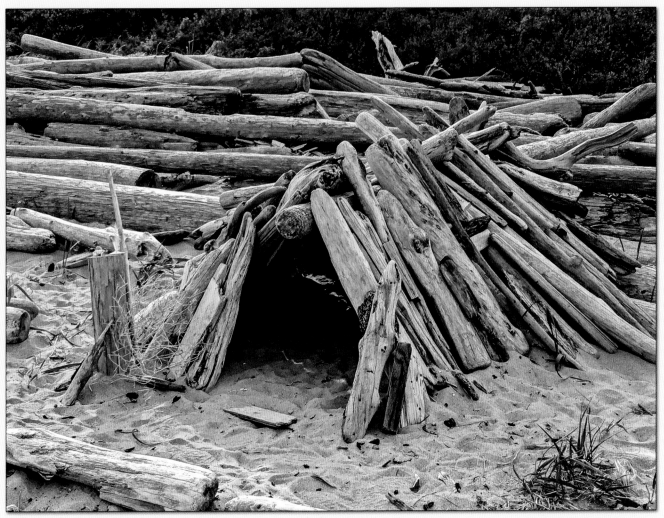

MARIN COUNTY

LEFT: SOUTH SALMON CREEK BEACH
NOTE TWO WHALE VERTEBRAE

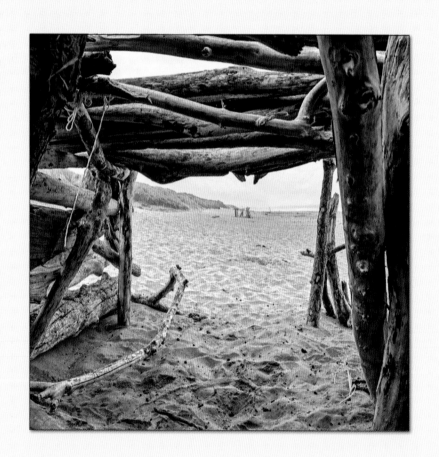

SOUTH SALMON CREEK BEACH

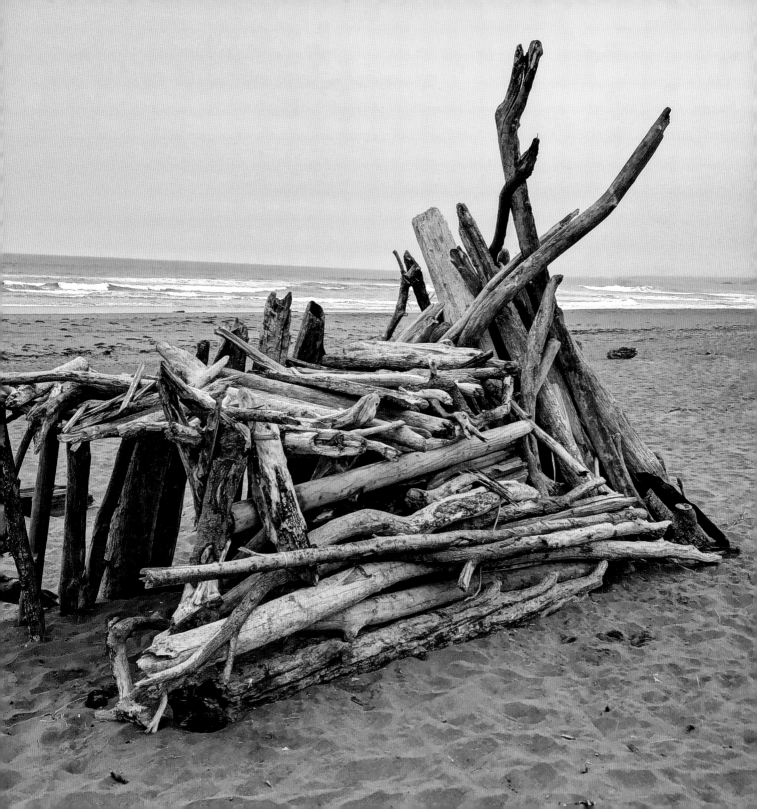

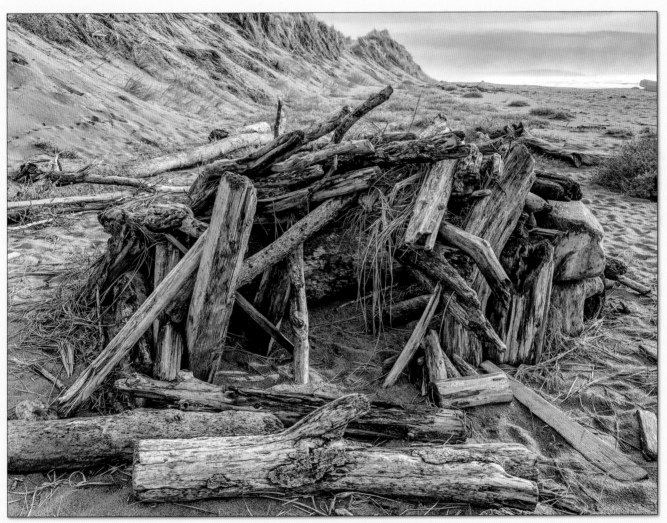

SOUTH SALMON CREEK BEACH

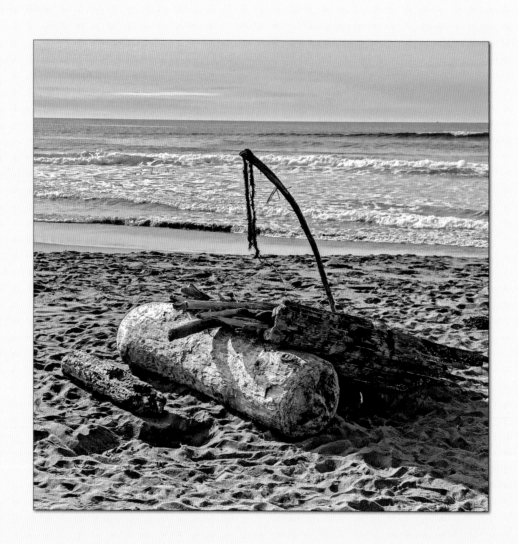

SOUTH SALMON CREEK BEACH

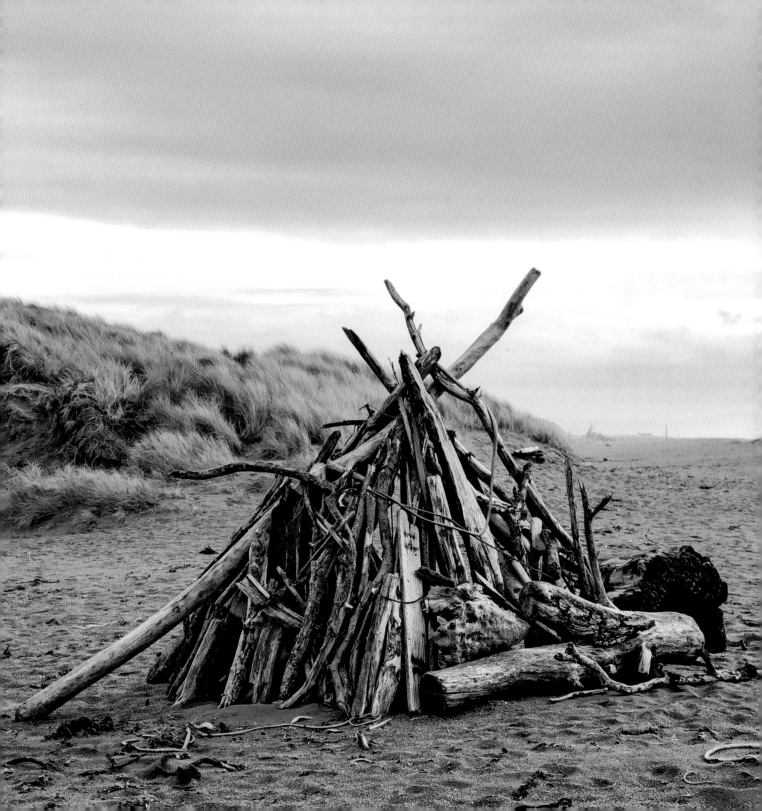

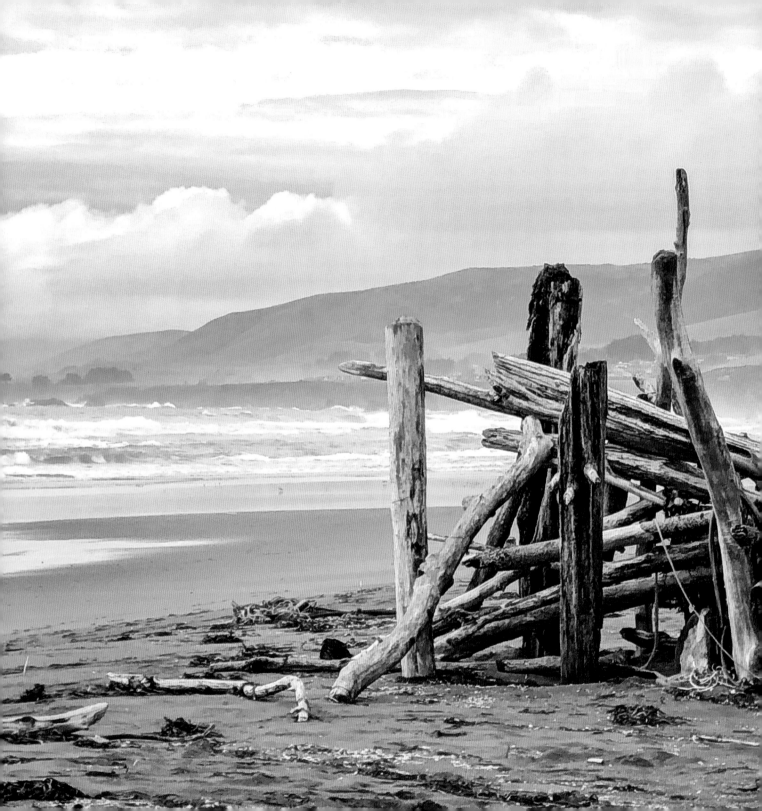

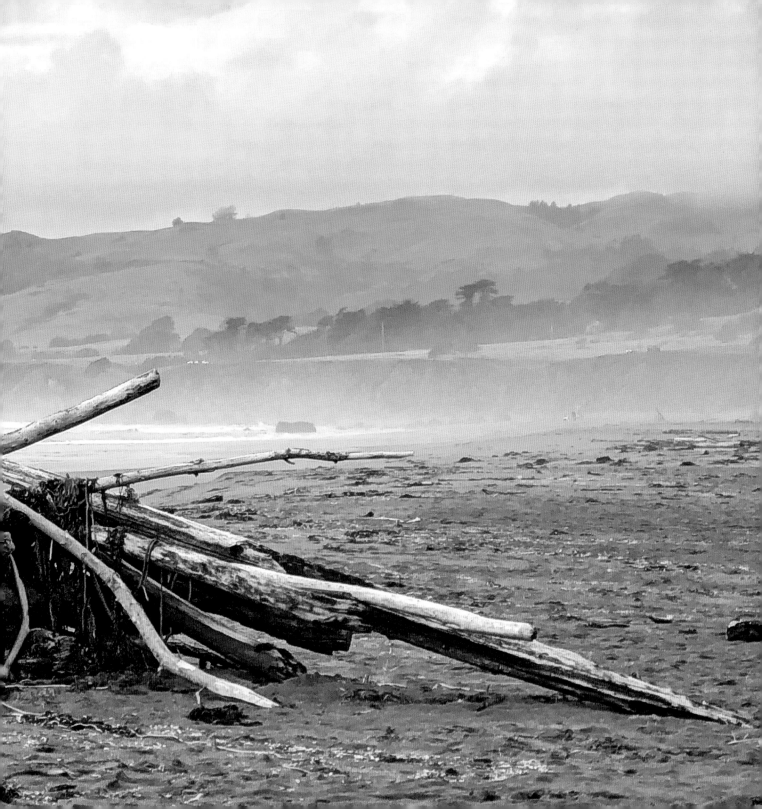

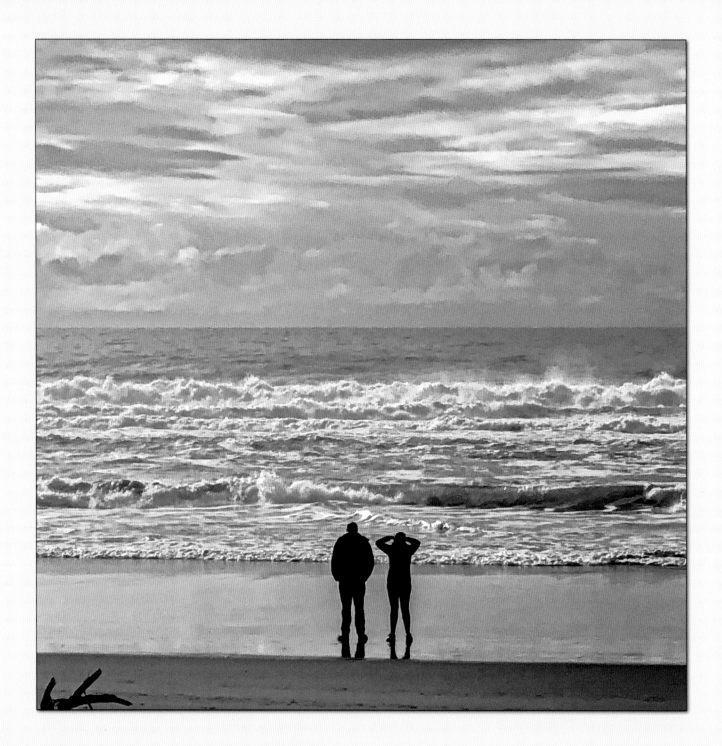

PREVIOUS TWO PAGES: NORTH SALMON CREEK BEACH

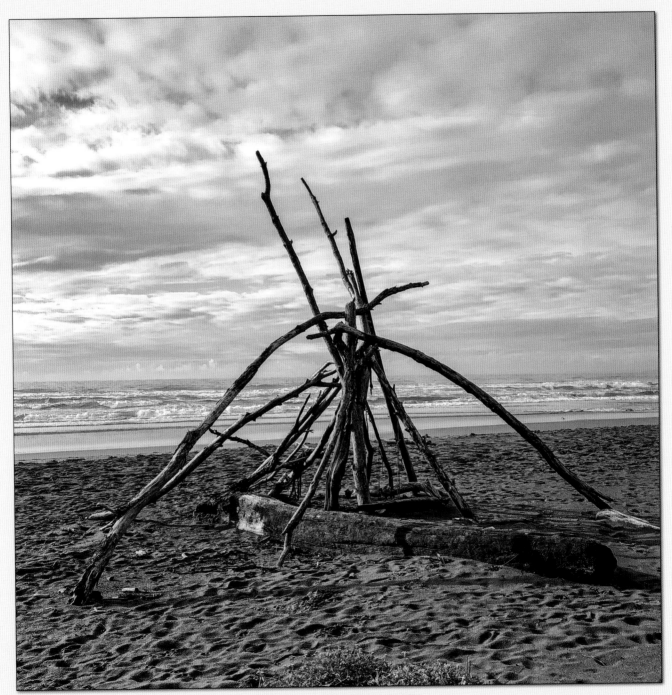

NORTH SALMON CREEK BEACH

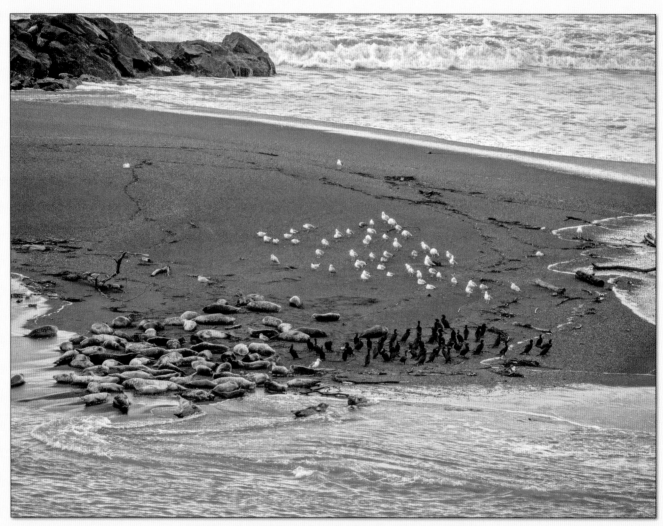

MOUTH OF RUSSIAN RIVER AT JENNER, SONOMA COUNTY

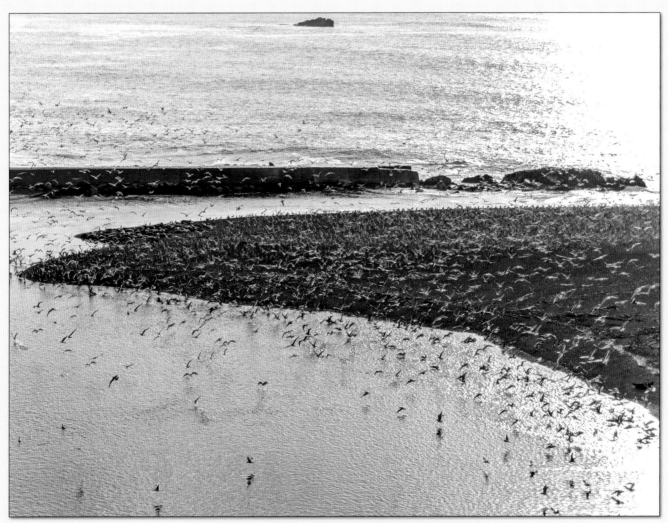

MOUTH OF RUSSIAN RIVER AT JENNER, SONOMA COUNTY

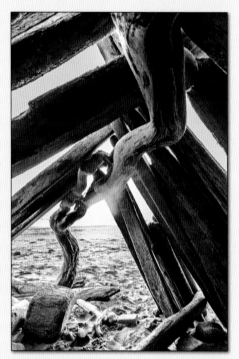

IT WAS A PERFECT ENDING TO FINISHING
A BOOK ON PACIFIC COAST BUILDERS.

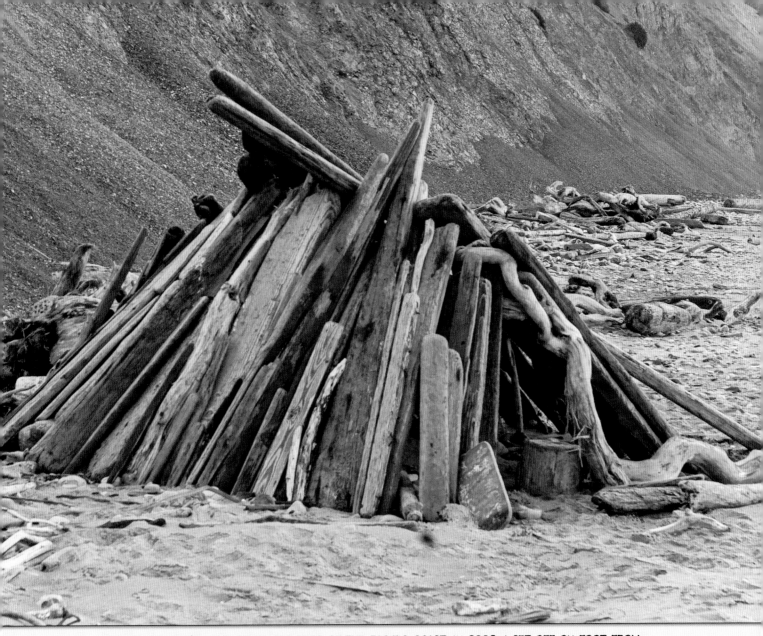

THE DAY I FINISHED OUR BOOK, BUILDERS OF THE PACIFIC COAST, IN 2008, I SET OFF ON FOOT FROM
HOME WITH A BACKPACK AND AFTER ABOUT AN HOUR'S HIKE CAME UPON THIS LITTLE HOME. PERFECT!
I UNROLLED MY SLEEPING BAG, EXPLORED THE BEACH, CAME BACK, WATCHED THE SUNSET FROM INSIDE,
THEN COOKED MY DINNER OVER A WOOD FIRE, AND SLEPT UNDER THE STARS.

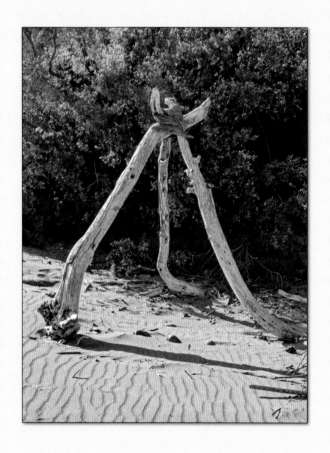

MARIN COUNTY

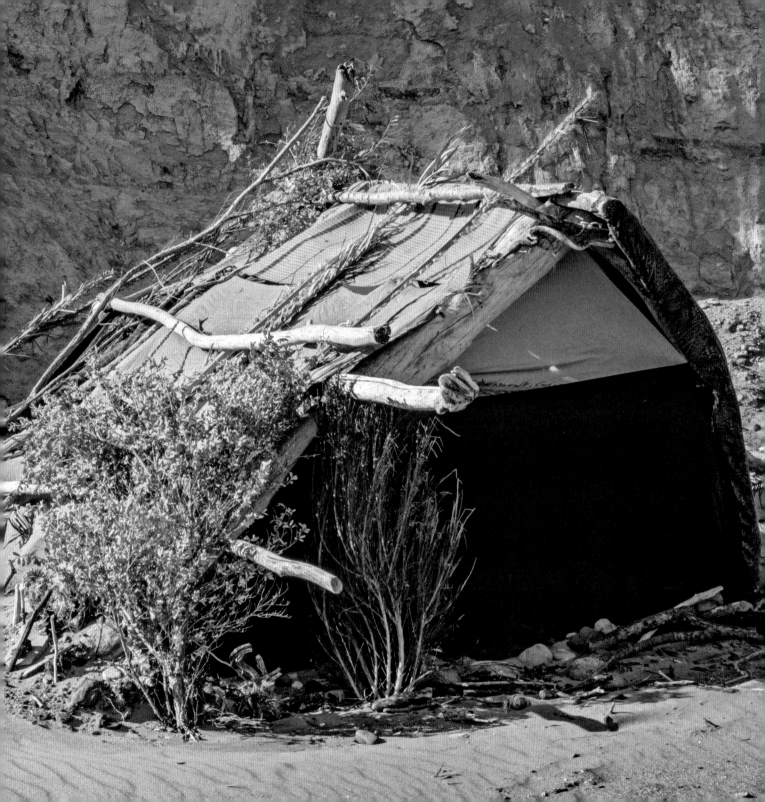

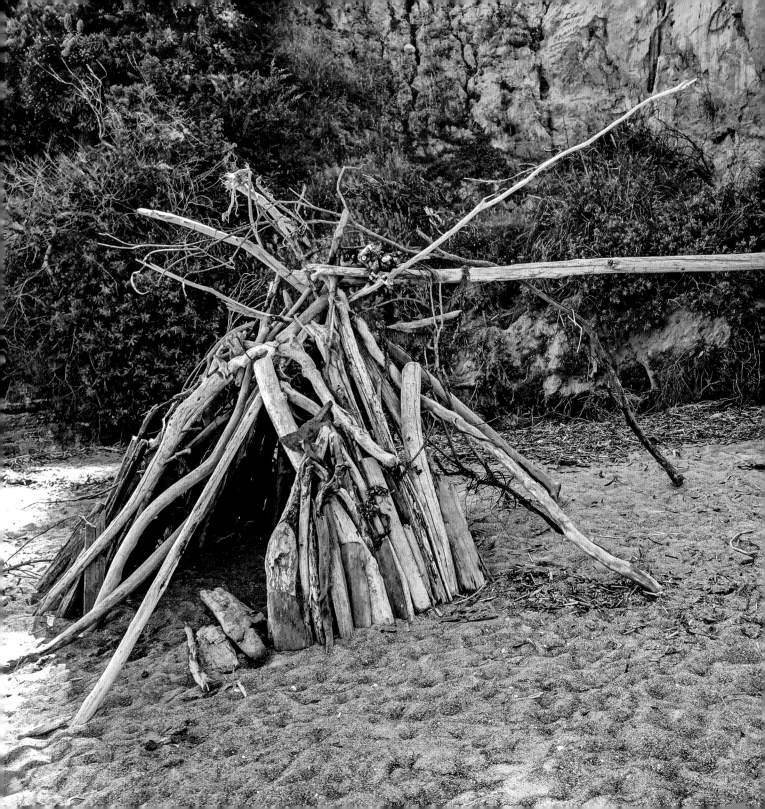

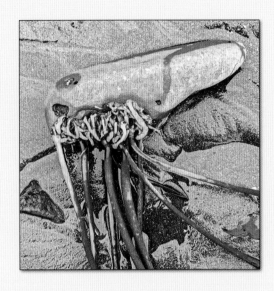

MARIN COUNTY

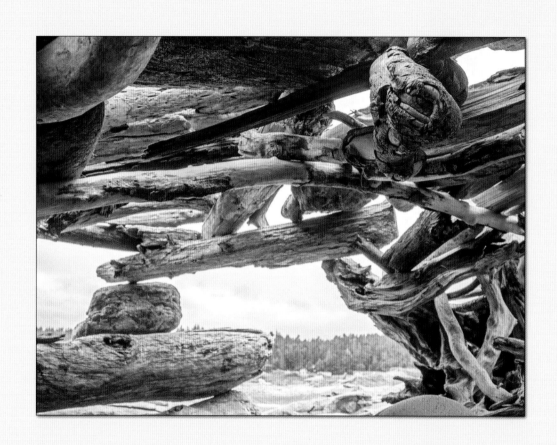

GUALALA POINT REGIONAL PARK
(INTERIOR AT LEFT)

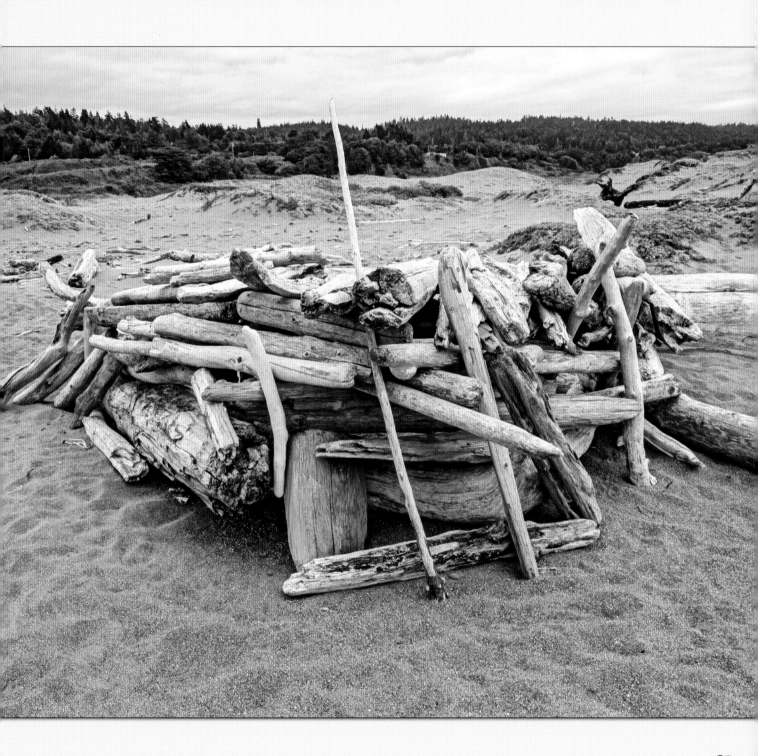

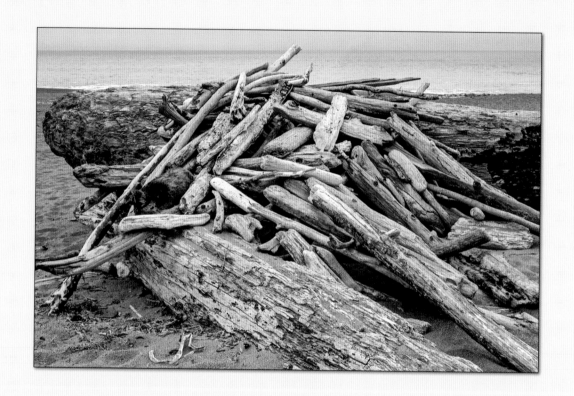

GUALALA POINT REGIONAL PARK

FOLLOWING TWO PAGES: STINSON BEACH

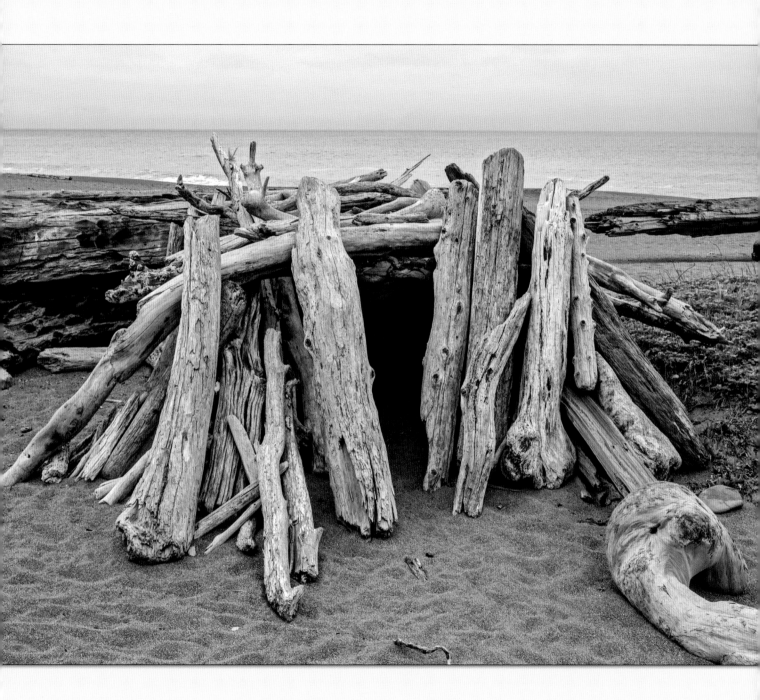

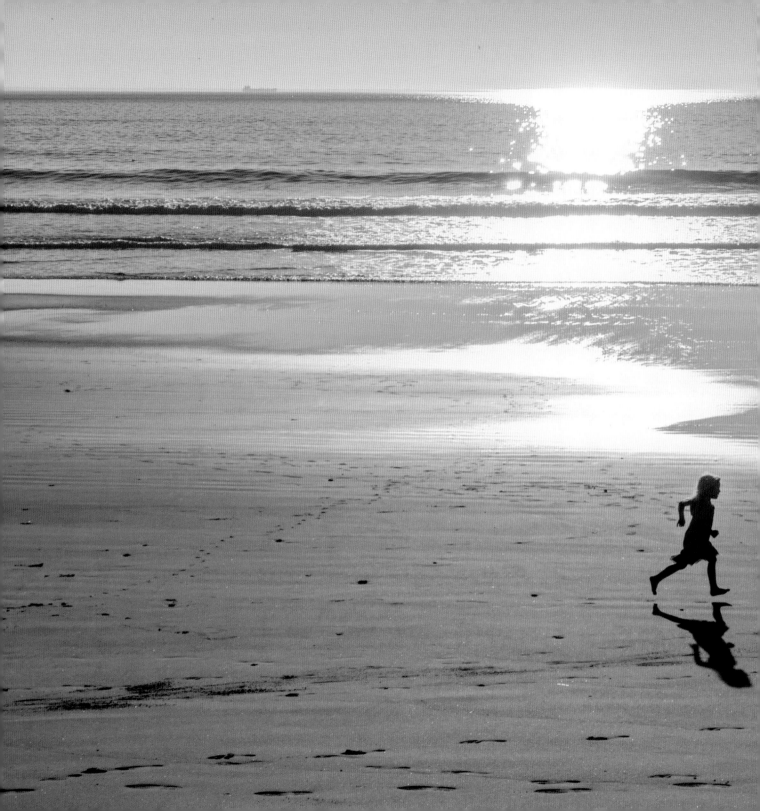

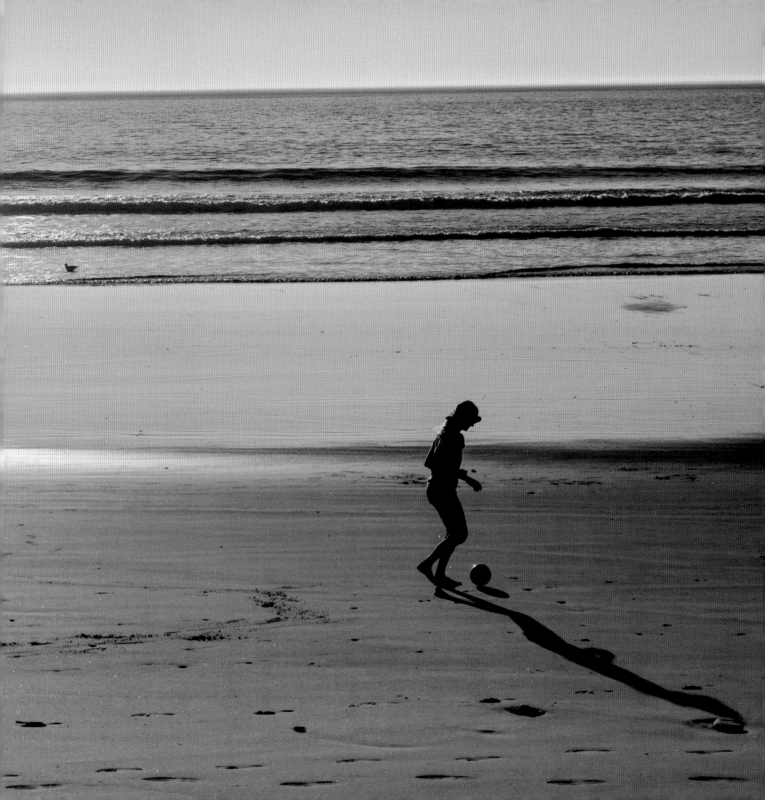

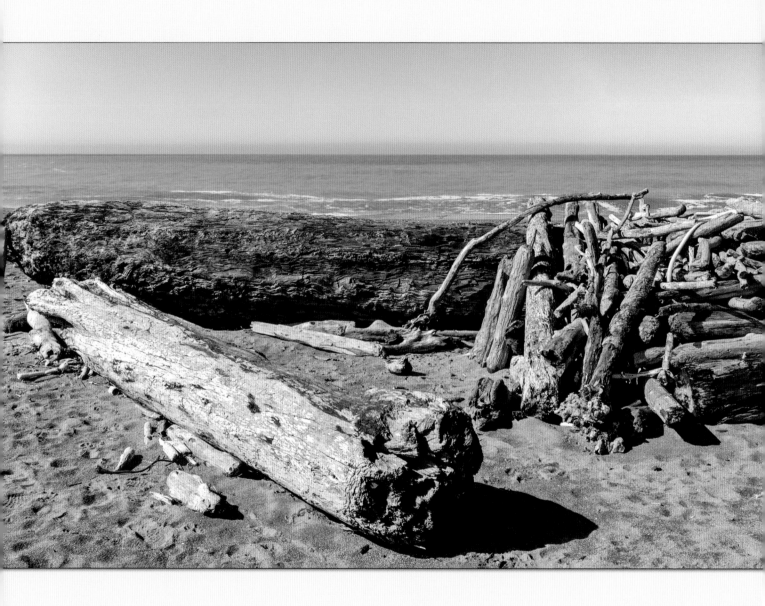

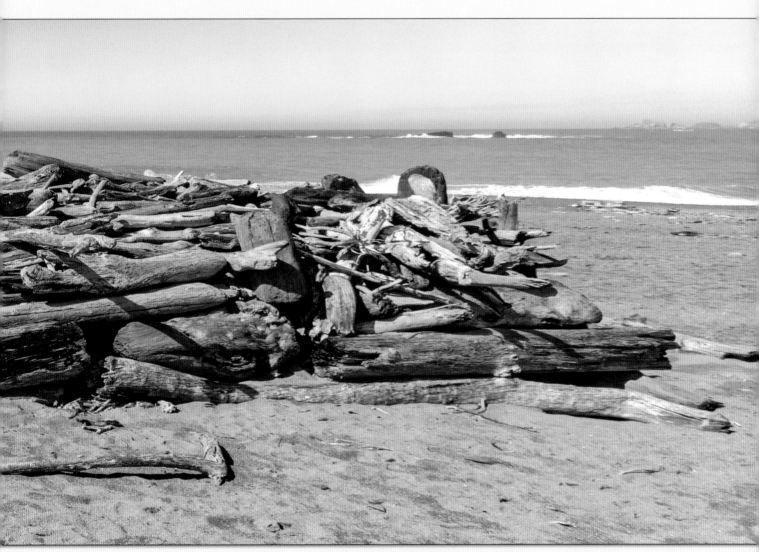

GUALALA POINT REGIONAL PARK

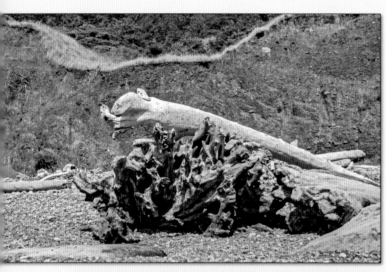

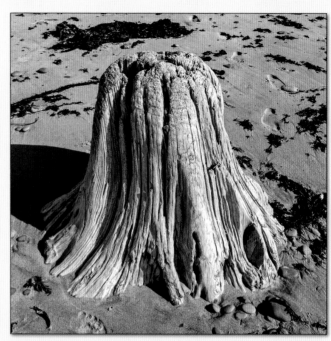

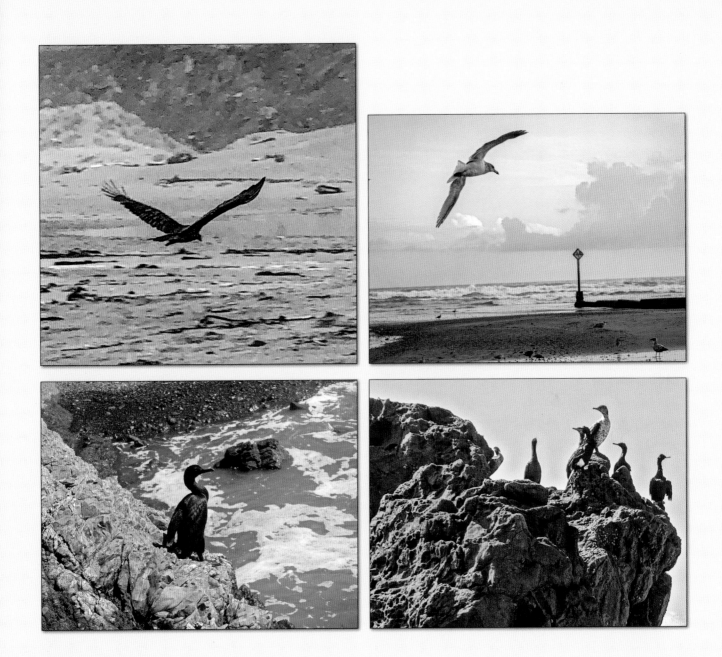

FOLLOWING TWO PAGES:
NORTH SALMON CREEK BEACH

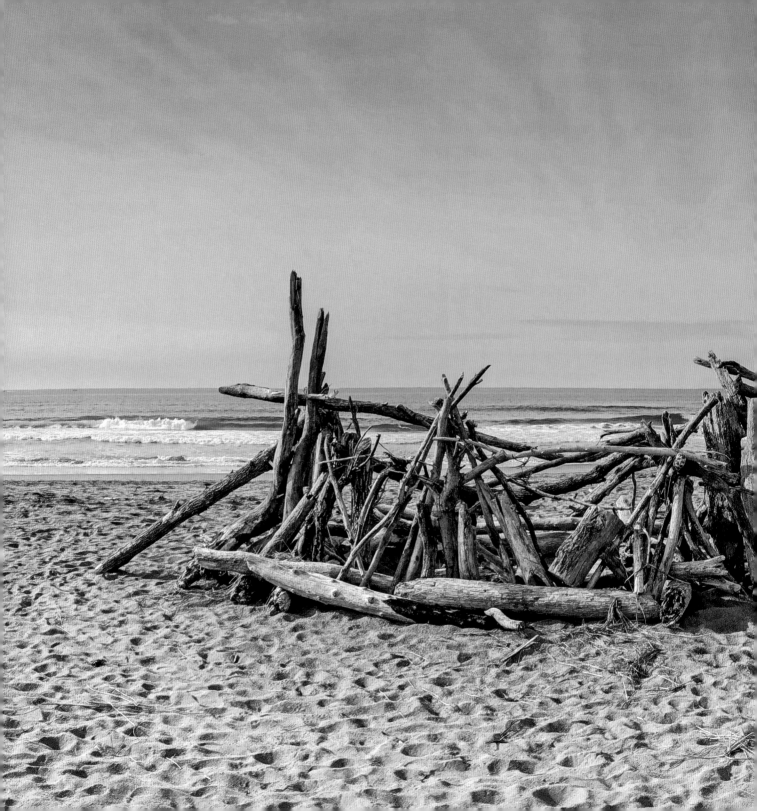

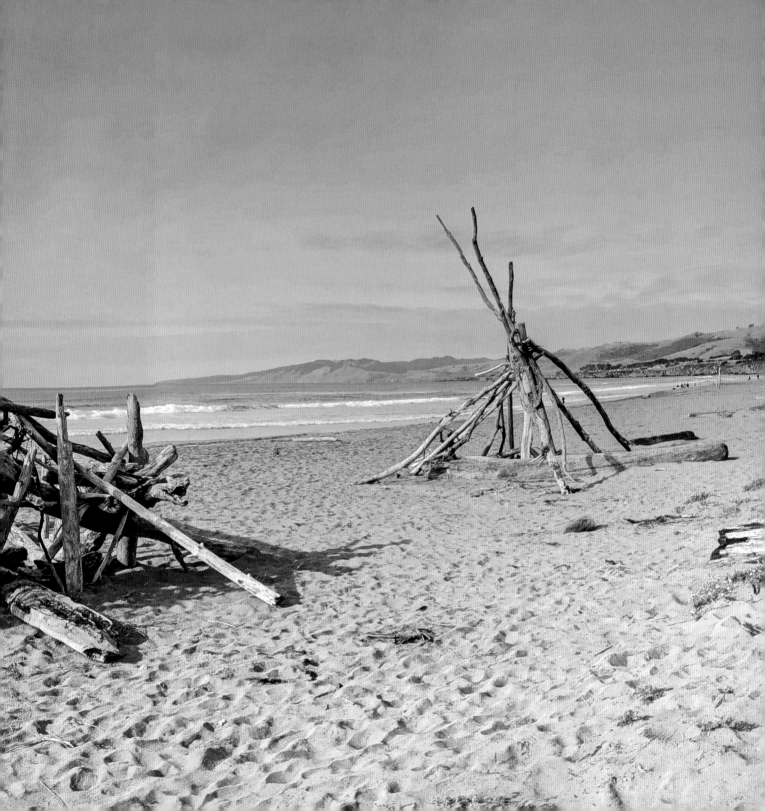

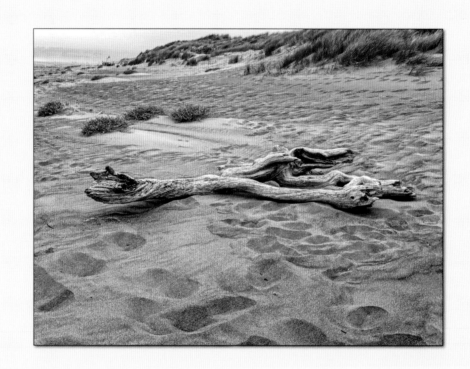

SOUTH SALMON CREEK BEACH

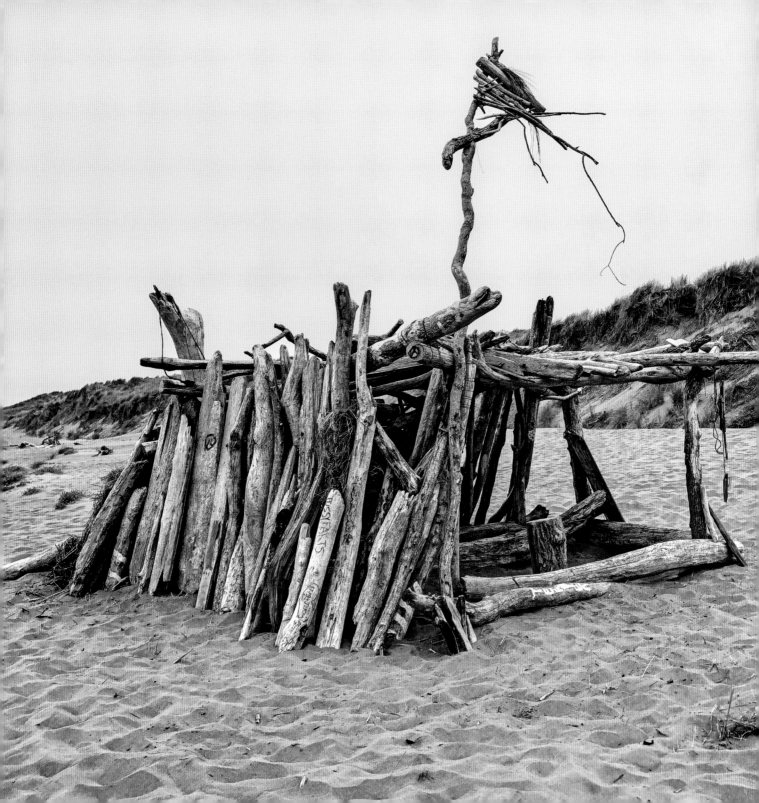

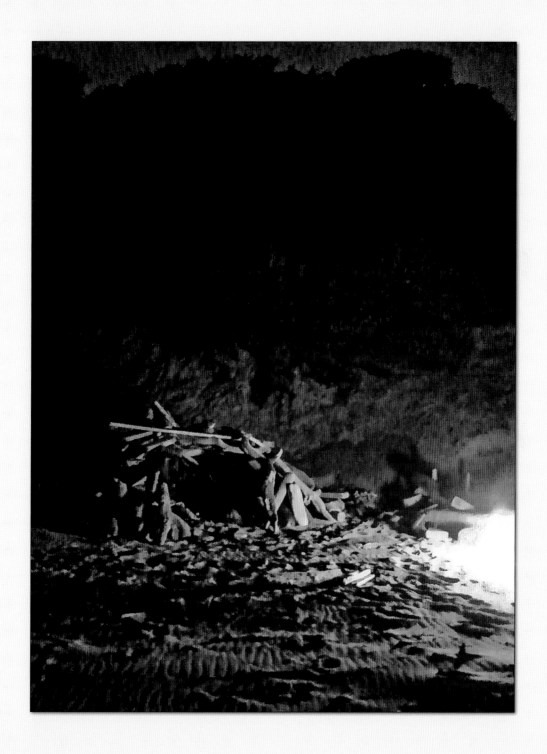

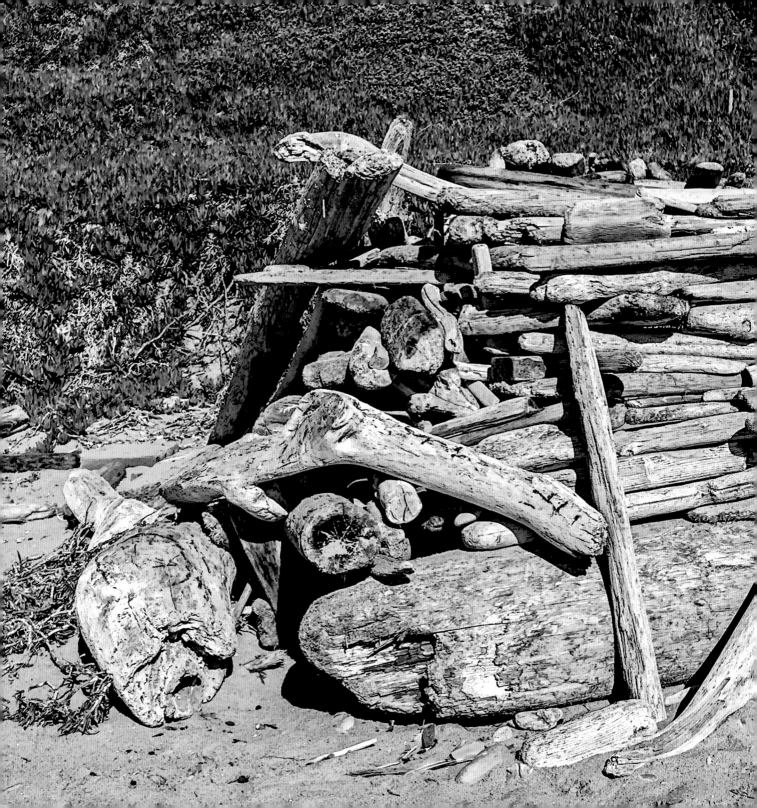

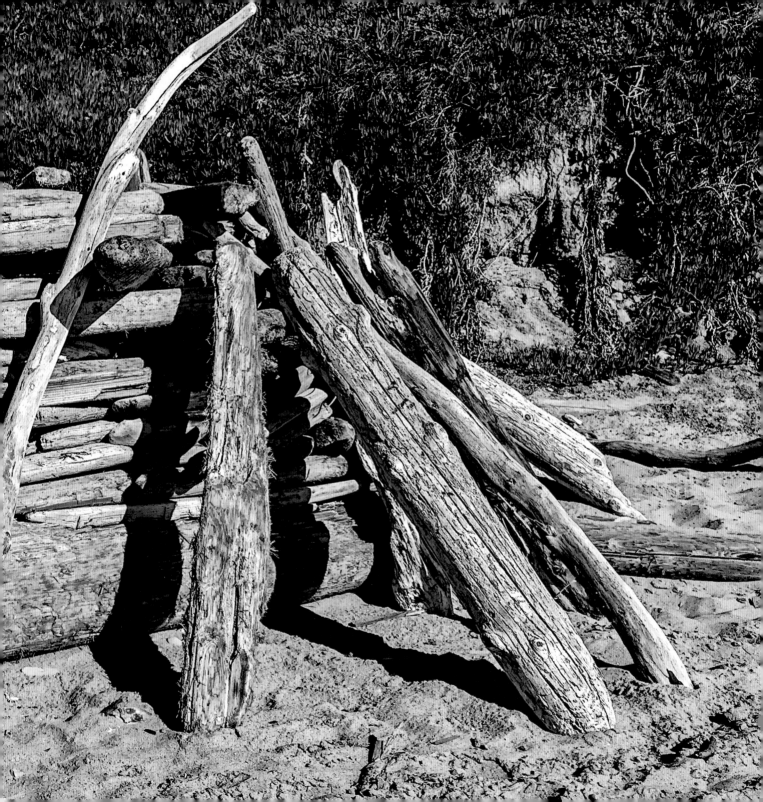

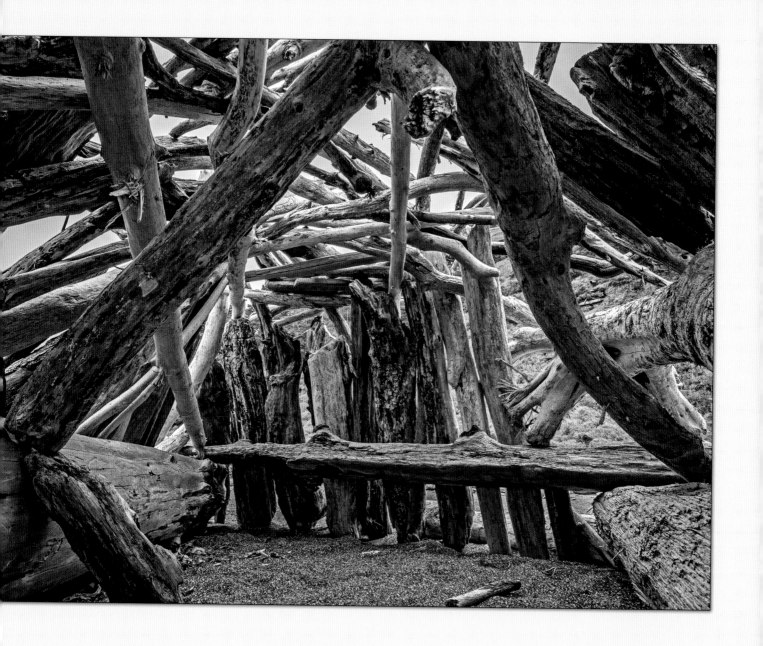

NAVARRO BEACH, INTERIOR & EXTERIOR

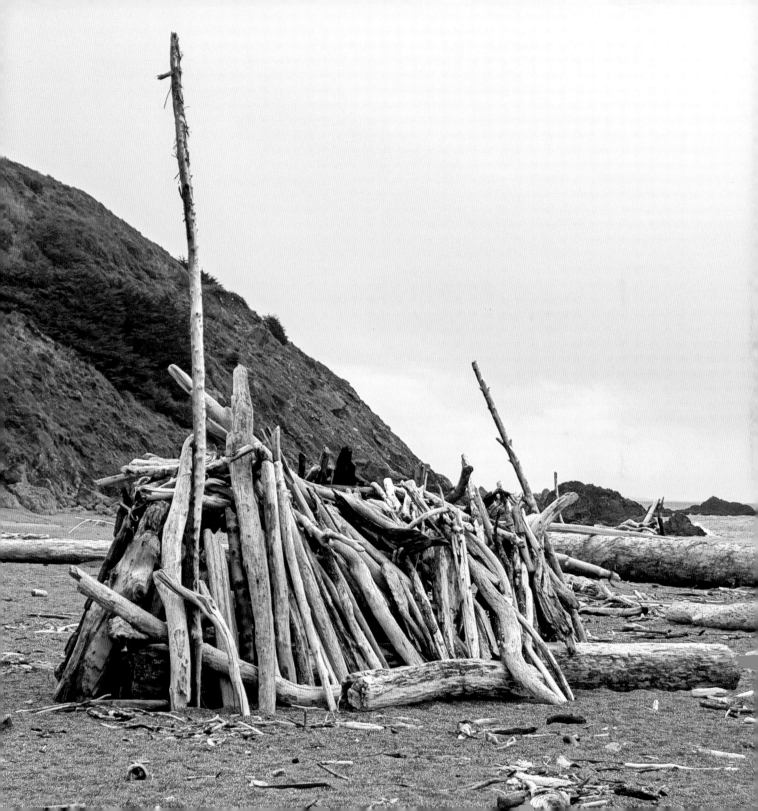

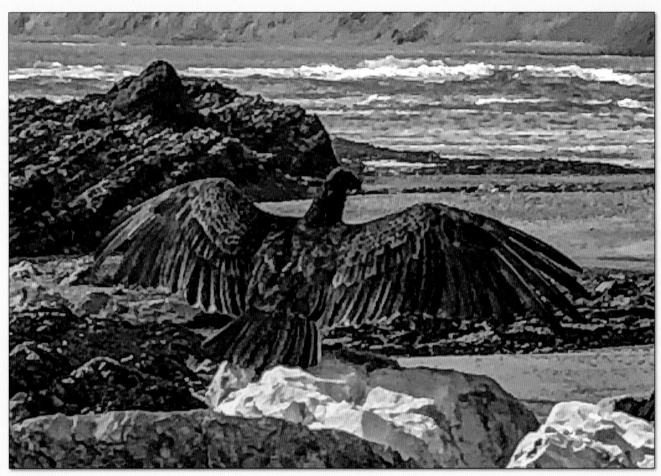

TURKEY VULTURE

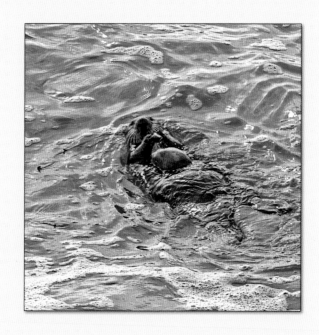

SEA OTTER IN KELP BEDS IN MARIN COUNTY, HOLDING AN ABALONE. THEY ARE DELIGHTFUL LITTLE
CREATURES. IN THE '50s IN SANTA CRUZ, THERE WAS A FRIENDLY LITTLE OTTER THAT USED TO COME
RIGHT UP TO OUR SURFBOARDS AT THE WILD HOOK; WE CALLED HIM SAMMY, THE SEA OTTER.

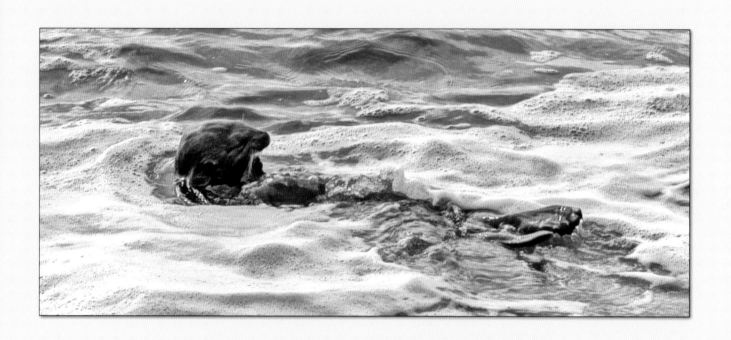

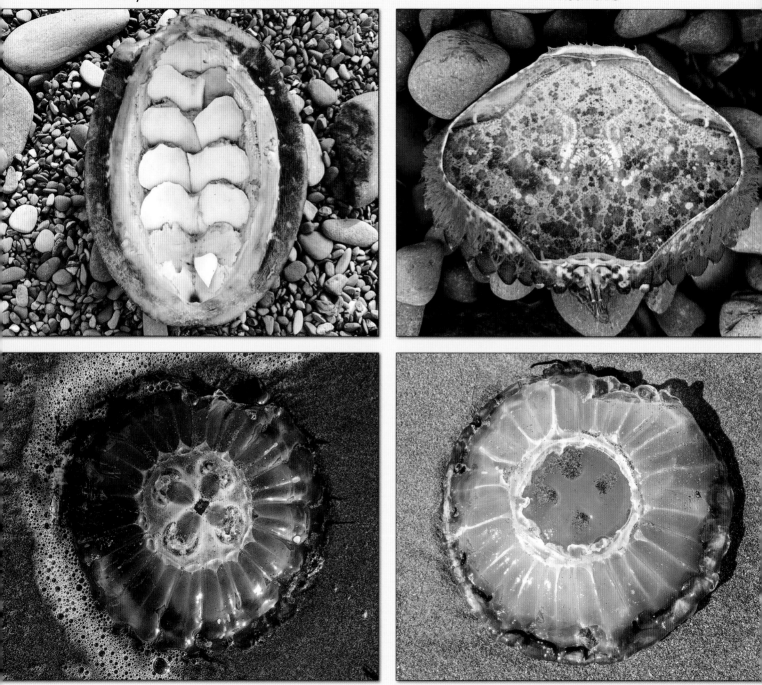

CHITON, OR "COAT-OF-MAIL SHELL"

ROCK CRAB

MOON JELLYFISH (LEFT AND RIGHT)

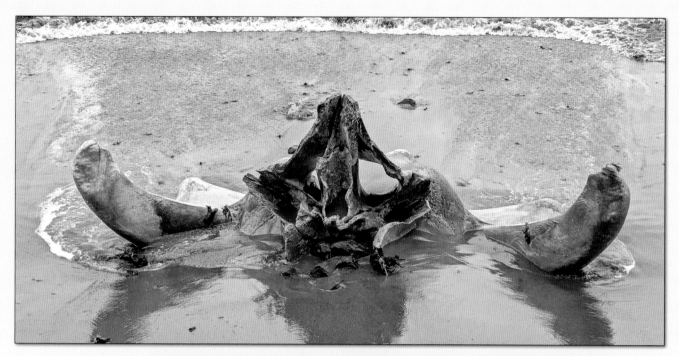

BONES OF
79-FOOT BLUE
WHALE THAT
WASHED UP
ON A MARIN
COUNTY BEACH
IN MARCH, 2018

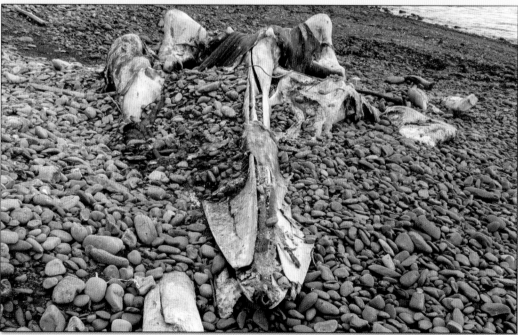

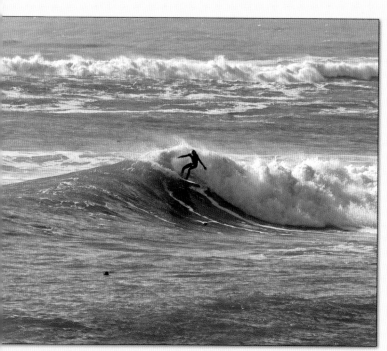

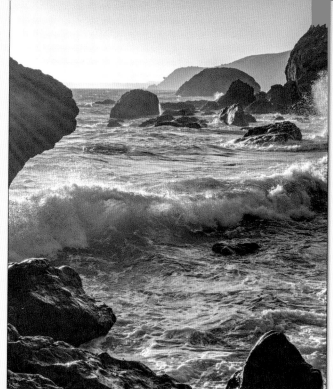

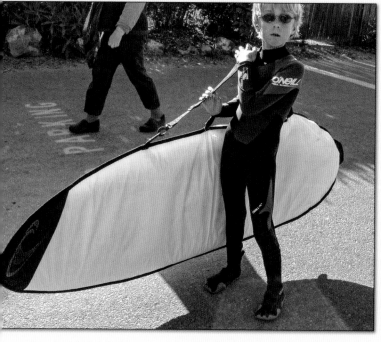

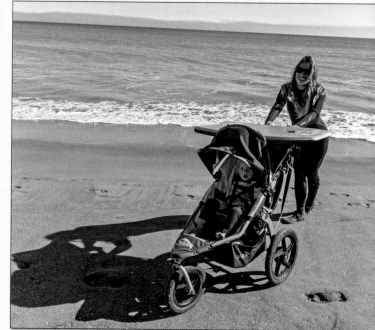

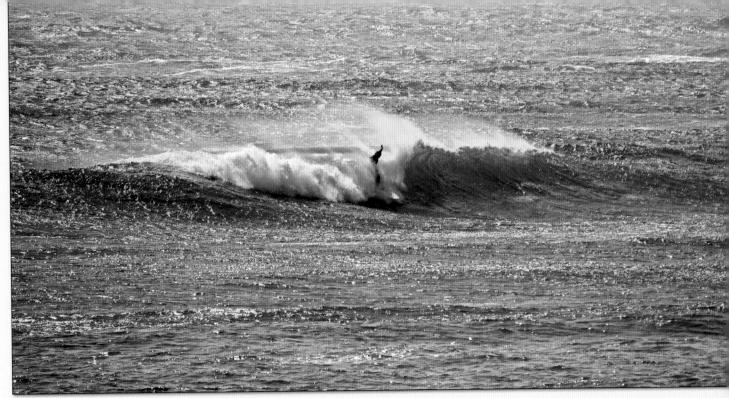

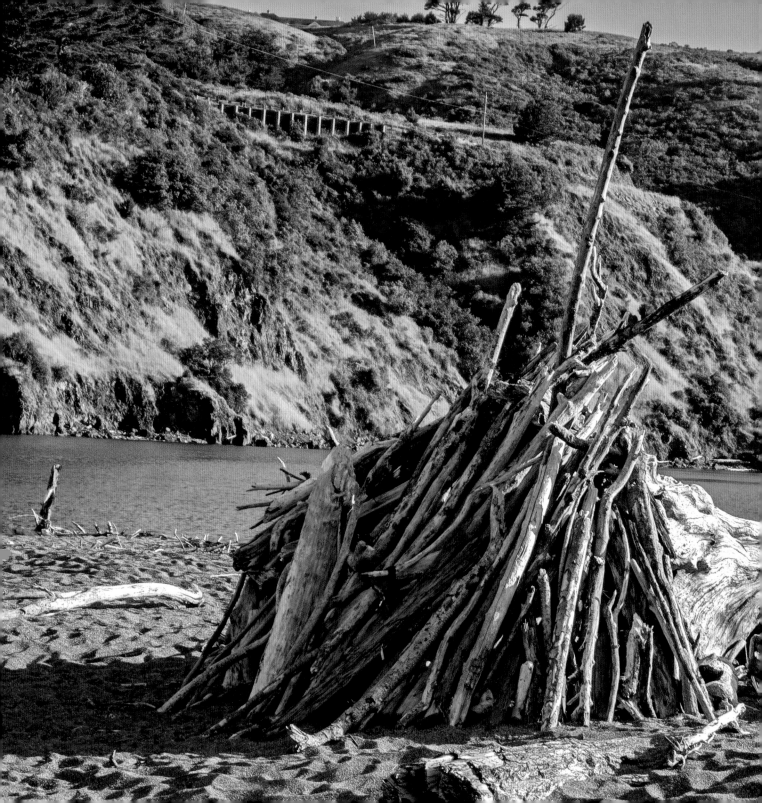

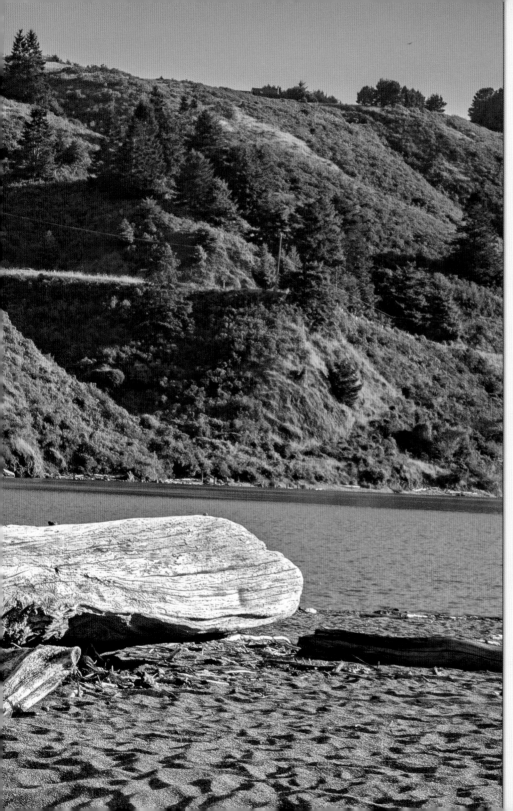

NAVARRO BEACH

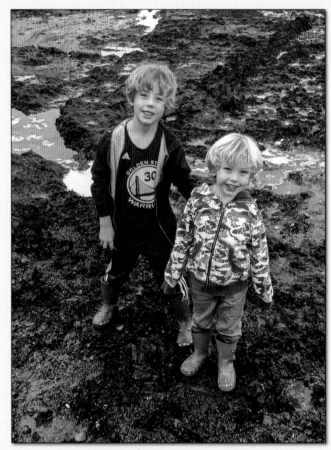

FOURTH-GENERATION BAY AREA BEACHCOMBERS,
GRANDSONS MACEO AND NIKKO
ON DUXBURY REEF, MARIN COUNTY

PERFECT LITTLE SUNBATHING/SWIMMING BEACH,
SHELTER COVE, HUMBOLDT COUNTY

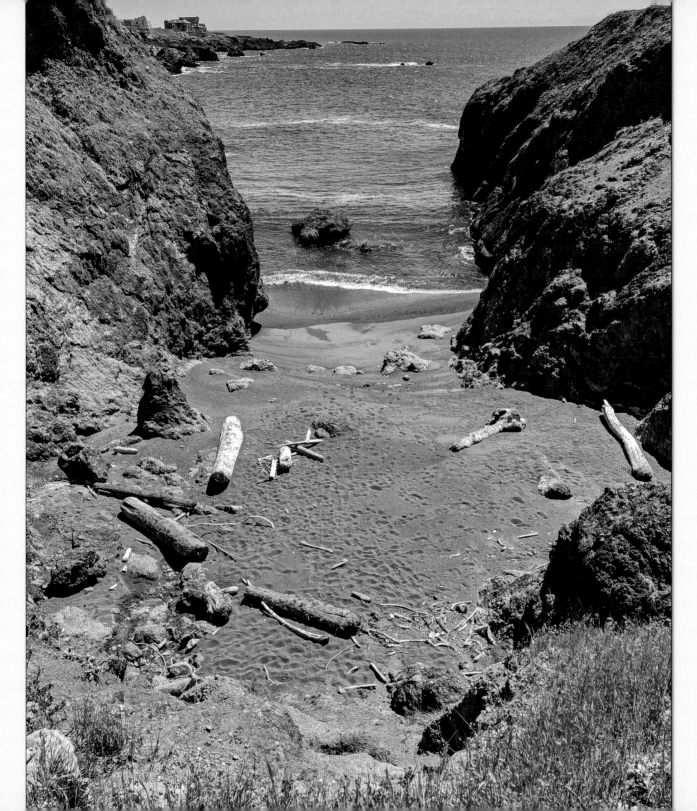

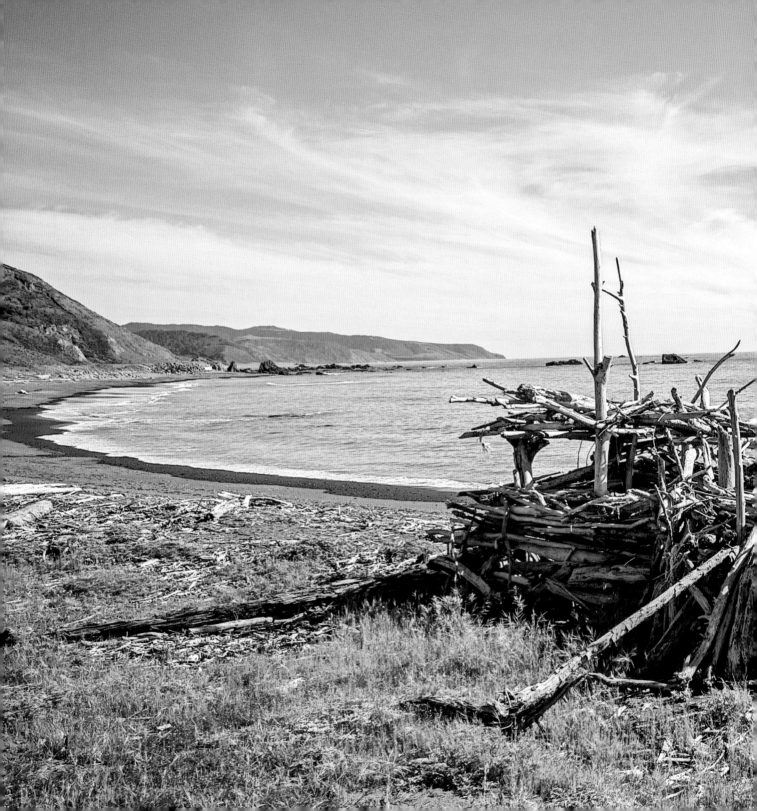

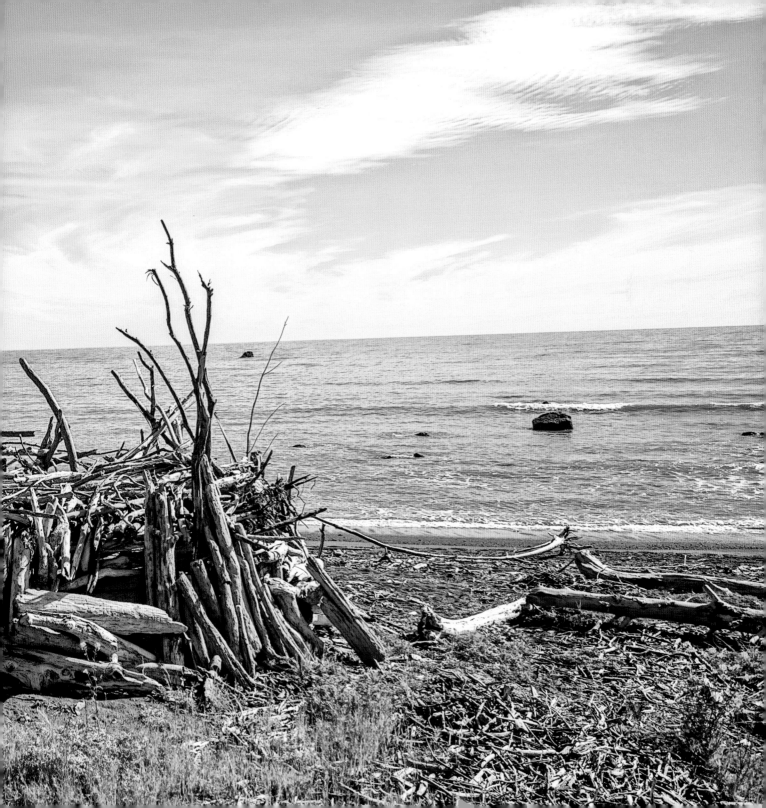

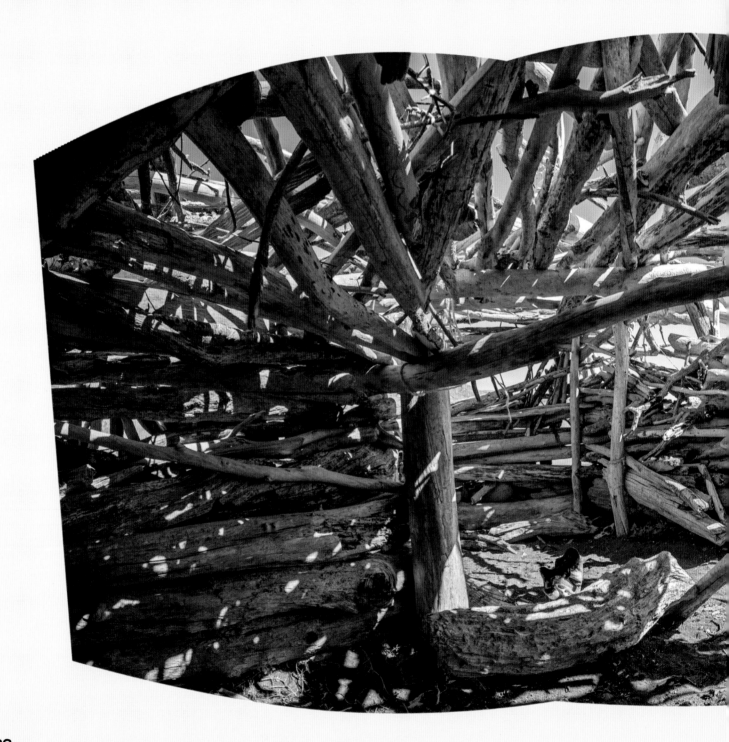

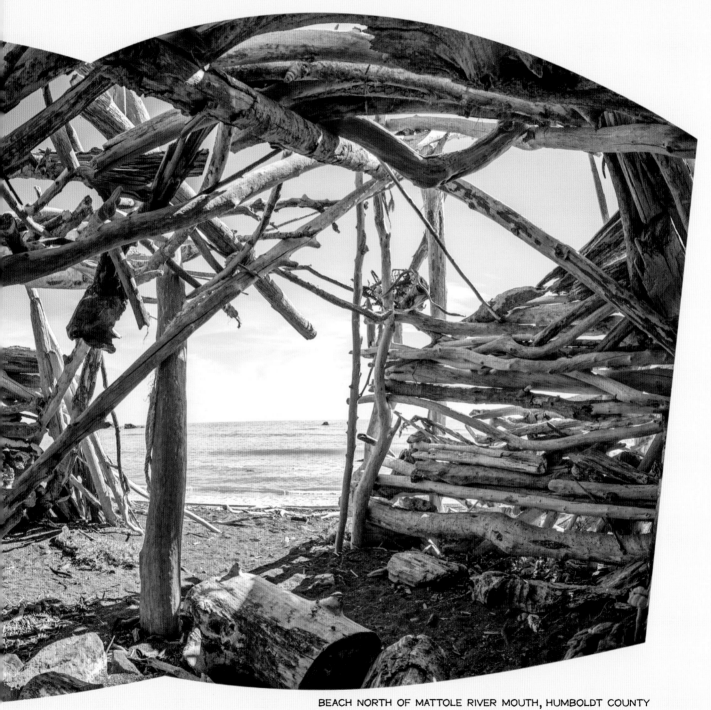

BEACH NORTH OF MATTOLE RIVER MOUTH, HUMBOLDT COUNTY
(SEE PREVIOUS PAGE FOR EXTERIOR)

THE LOST COAST

AS MY LAST BEACH TRIP, I DECIDED TO HIKE THE LOST COAST, A 25-MILE STRETCH OF BEACH IN HUMBOLDT COUNTY TO WHICH THERE ARE NO ROADS. IT'S PART OF THE KING RANGE NATIONAL CONSERVATION AREA, WITH 4000-FOOT-HIGH PEAKS. THE ROUTE GOES FROM THE MOUTH OF THE MATTOLE RIVER SOUTH TO SHELTER COVE. IT'S LIKE A PREHISTORIC SCENE. YOU HAVE TO GET A PERMIT FROM THE BLM, AND RENT A BEAR CANISTER, IN WHICH YOU STORE ALL YOUR FOOD EACH NIGHT AND PUT IT AT LEAST 50 FEET AWAY FROM YOUR CAMPSITE. (BROWN BEARS PATROL THE BEACHES.)

THERE ARE TWO SECTIONS, EACH 3-4 MILES LONG THAT ARE "INACCESSIBLE AT HIGH TIDE." YOU ARE WARNED THAT YOU CAN DIE IF YOU GET CAUGHT THERE. WELL, UH, OK.

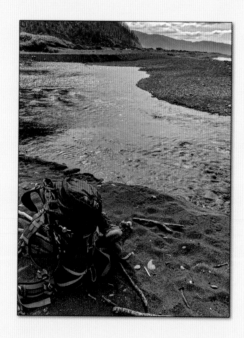

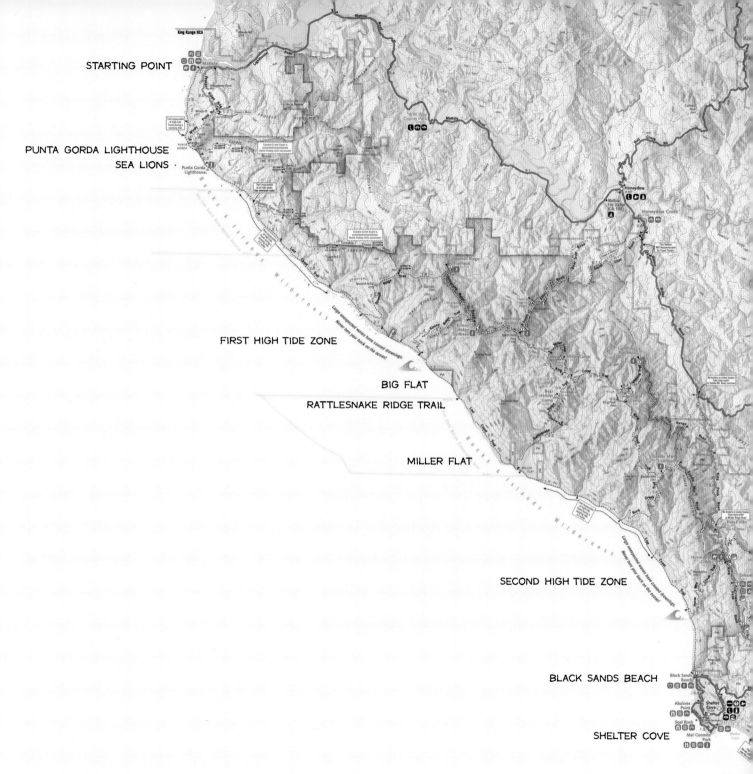

STARTING POINT

PUNTA GORDA LIGHTHOUSE
SEA LIONS

FIRST HIGH TIDE ZONE

BIG FLAT

RATTLESNAKE RIDGE TRAIL

MILLER FLAT

SECOND HIGH TIDE ZONE

BLACK SANDS BEACH

SHELTER COVE

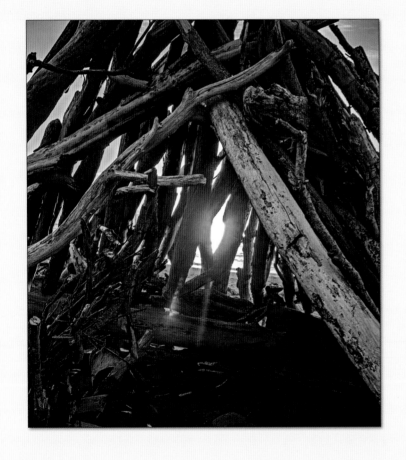

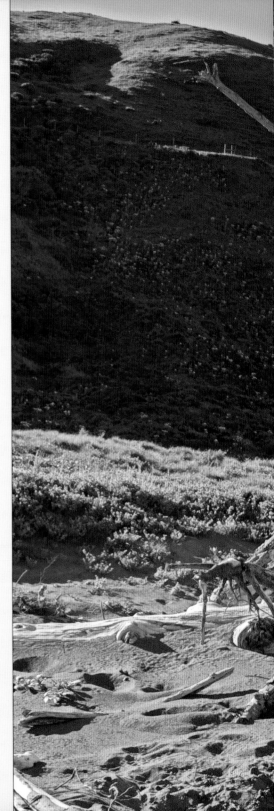

AT RIGHT: MATTOLE RIVER MOUTH THE MORNING I STARTED, ABOUT 10:30 AM

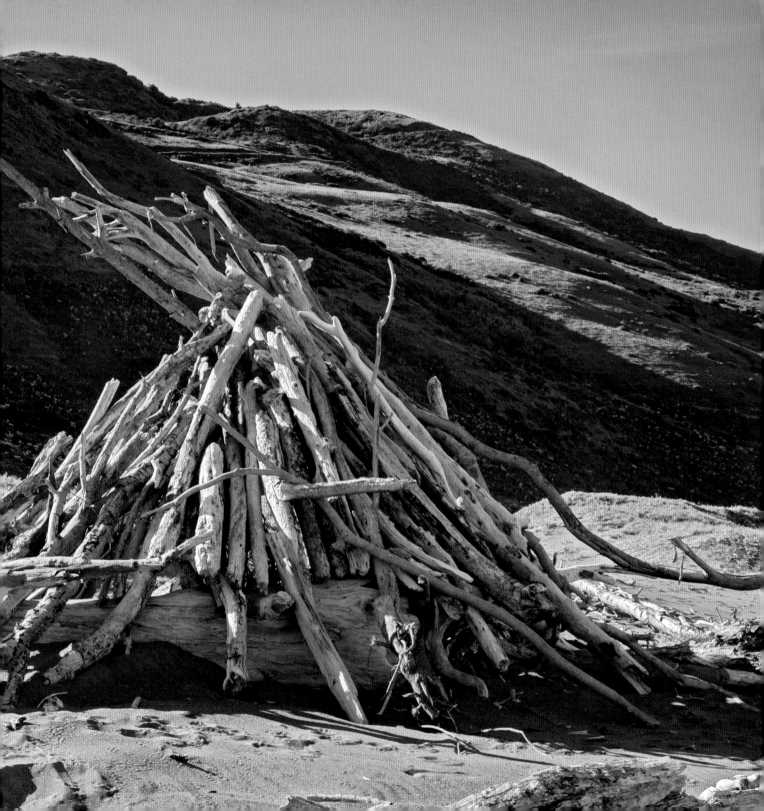

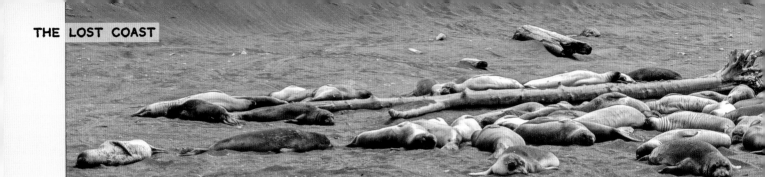

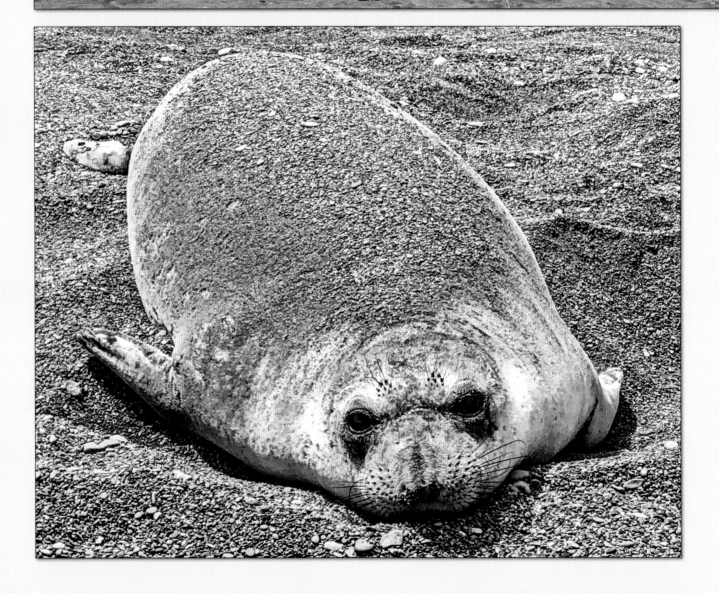

AFTER ABOUT AN HOUR THE FIRST DAY, I GOT TO THE DESERTED PUNTA GORDA LIGHTHOUSE; THERE WAS A LARGE COLONY OF ELEPHANT SEALS. THEY WERE OBLIVIOUS TO HUMANS, UNDOUBTEDLY ACCUSTOMED TO ALL THE HIKERS THAT WALK ON THIS BEACH.

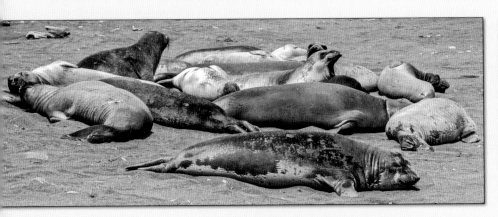

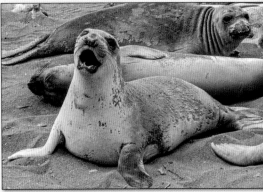

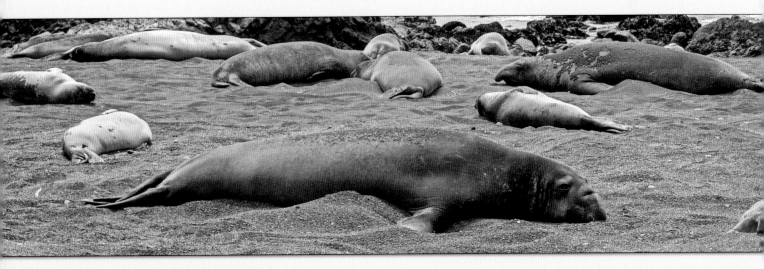

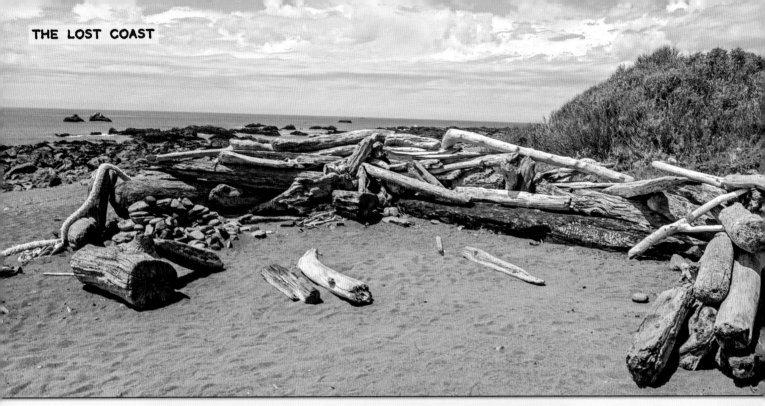

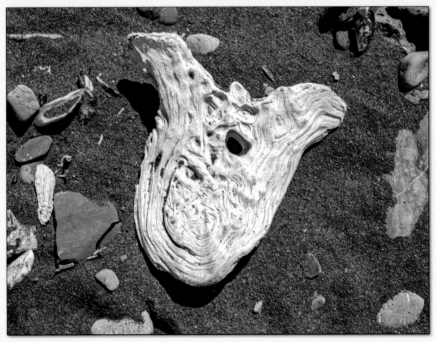

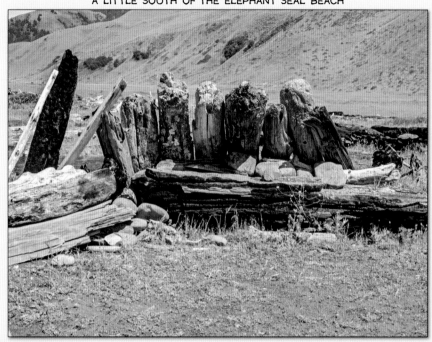

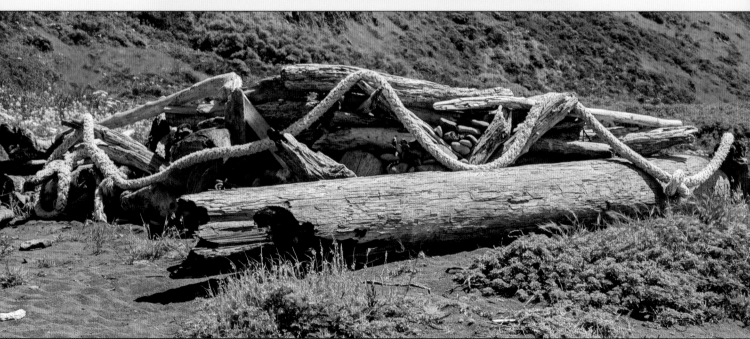

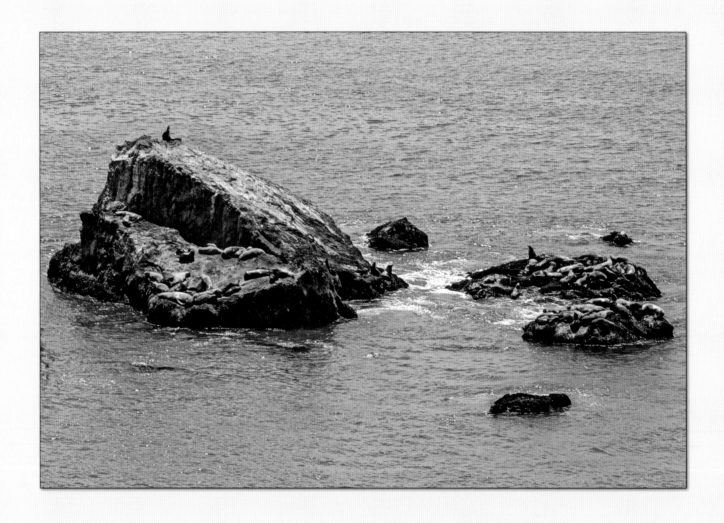

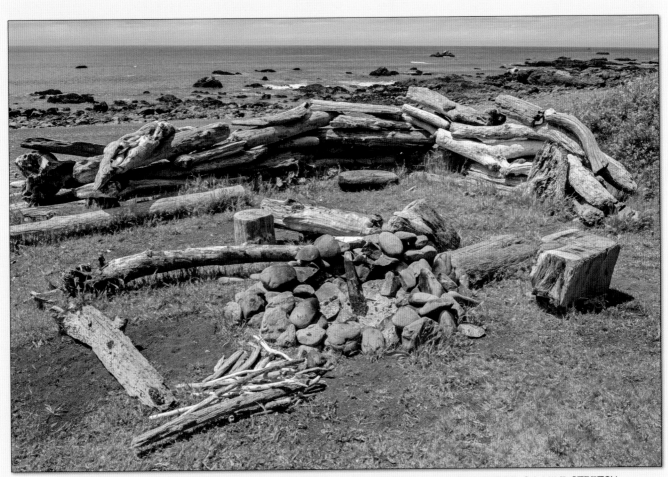

IT SURPRISED ME: THERE WAS VIRTUALLY NO GARBAGE OR PLASTIC ALONG THE ENTIRE 25-MILE STRETCH.

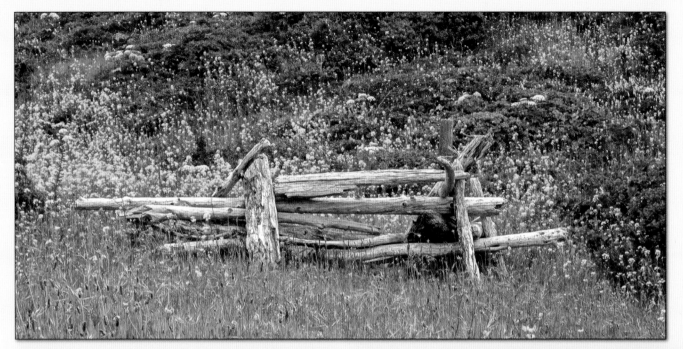

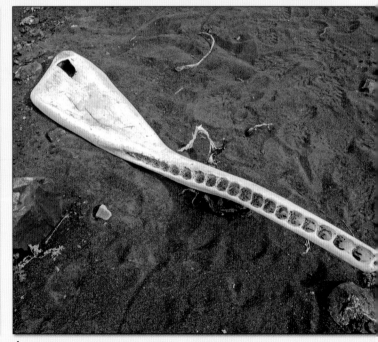

I'M GUESSING THAT THIS IS THE JAWBONE
OF A SMALL SPERM WHALE.

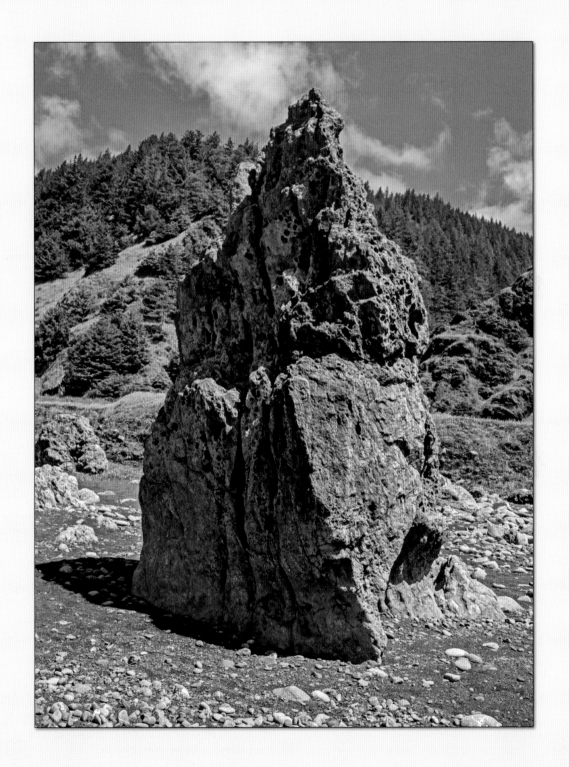

NEAR THE END OF THE FIRST DAY, I GOT TO THE FIRST HIGH-TIDE
AREA AND DECIDED I COULDN'T MAKE IT PAST THE SOUTHERN POINT.
I FOUND A LEDGE ABOVE THE WATER, PITCHED MY TENT ON THE
ROCKY GROUND, HOPING I'D BE ABOVE THE HIGH TIDE THAT NIGHT.
(I WAS.)

I HAD TO WAIT A FEW HOURS IN THE MORNING FOR THE TIDE TO
DROP SO I COULD GET AROUND THE POINT. I WAS ABLE TO FOLLOW
A TRAIL ON THE BLUFF FOR A WHILE (EASY WALKING) — *(SEE PHOTO
ON OPPOSITE PAGE)*. THEN I WENT DOWN THROUGH THE CANYON
SHOWN IN THE PHOTO, JUMPED THE CREEK, AND WALKED ON THE
BEACH SHOWN FOR A WAYS.

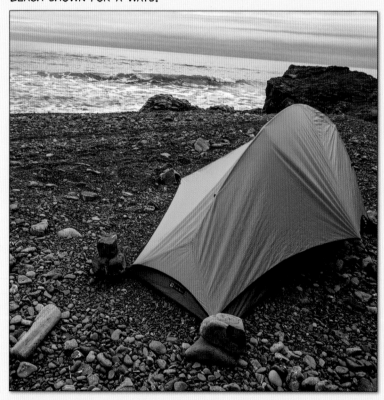

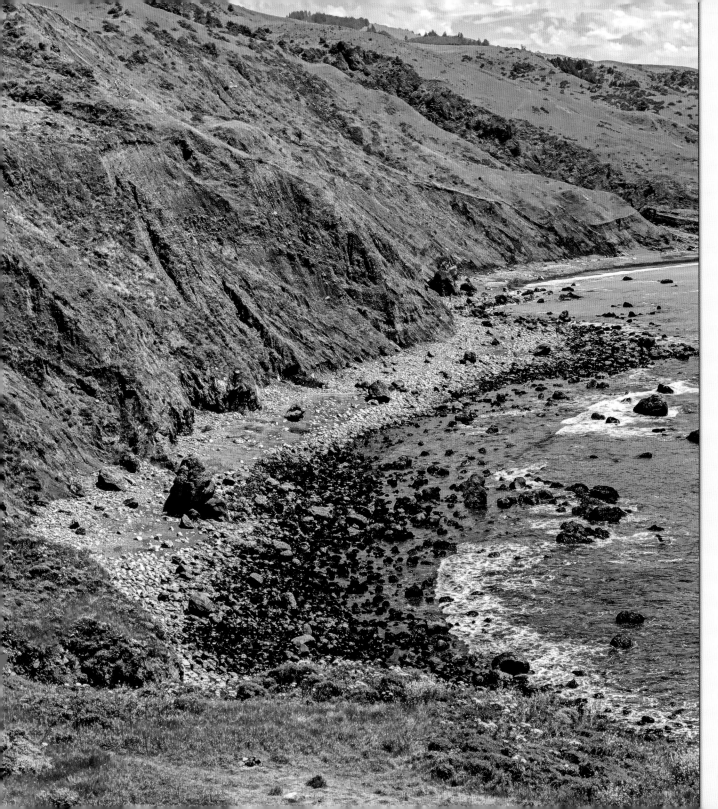

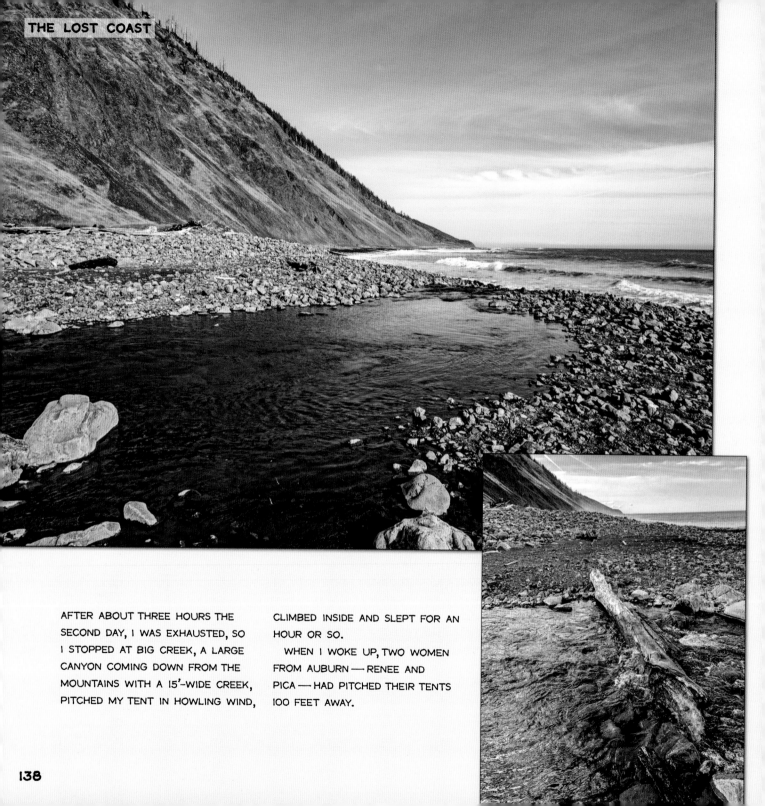

AFTER ABOUT THREE HOURS THE SECOND DAY, I WAS EXHAUSTED, SO I STOPPED AT BIG CREEK, A LARGE CANYON COMING DOWN FROM THE MOUNTAINS WITH A 15'-WIDE CREEK, PITCHED MY TENT IN HOWLING WIND, CLIMBED INSIDE AND SLEPT FOR AN HOUR OR SO.

WHEN I WOKE UP, TWO WOMEN FROM AUBURN — RENEE AND PICA — HAD PITCHED THEIR TENTS 100 FEET AWAY.

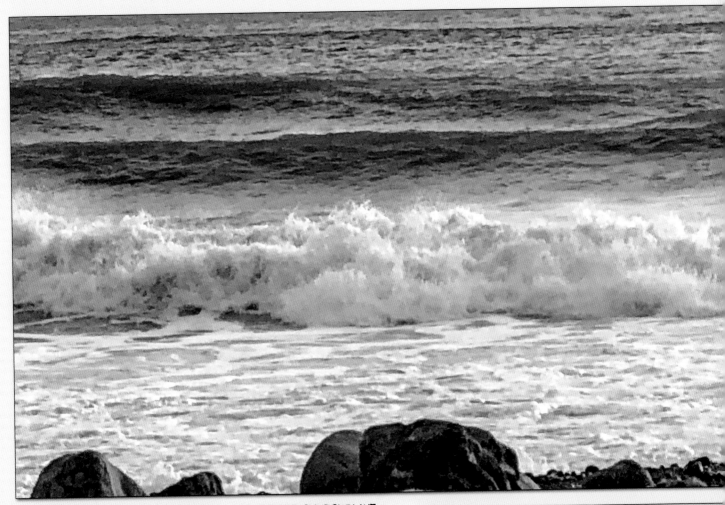

THE SURF CAME UP THAT AFTERNOON. JUST BEFORE SUNDOWN WE
SAW A FIGURE HEADING NORTH (INTO THE WIND), MOVING REALLY FAST.
HE GOT TO THE CREEK AND WITHOUT HESITATION, TIGHTROPE-WALKED
ACROSS THE SLIPPERY LOG. WE ALL SAT AROUND AND VISITED. HE HAD
VERY LITTLE EQUIPMENT — WAS GOING LIGHT. HE WAS FULL OF ENERGY,
WEARING RUNNING SHOES, AND WE TALKED ABOUT THE ROUTE FOR A
WHILE. HE TOLD US HOW TO GET UP ON A TRAIL ON THE BLUFF TO THE
SOUTH, AND THEN TOOK OFF, ALMOST RUNNING.

THAT NIGHT WE SAT AROUND THE LADIES' CAMPFIRE. PICA HAD
A LIGHTWEIGHT PLASTIC UKULELE AND SANG SONGS WITH A VERY
SWEET VOICE.

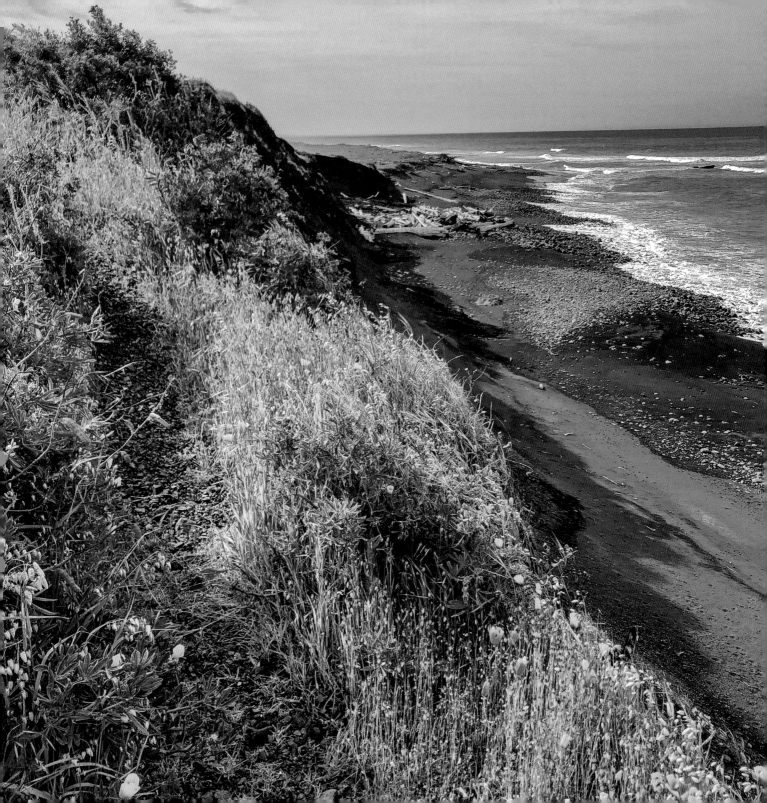

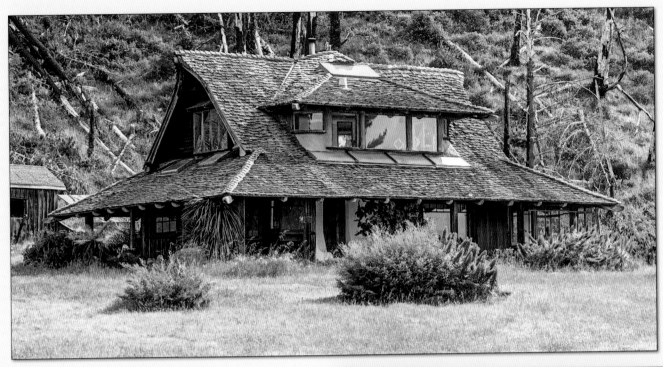

I TOOK OFF THE NEXT MORNING. I FELT A LOT BETTER. LUCKILY, I FOLLOWED LAST NIGHT'S HIKER'S DIRECTIONS ON HOW TO GET UP ON THE BLUFF TRAIL; OTHERWISE I WOULDN'T HAVE SEEN IT AND WOULD HAVE STRUGGLED THROUGH BEACH BOULDERS AND DEEP SAND. WALKING ON A TRAIL WAS A CINCH, AND, BEING SPRING, CALIFORNIA SUNSHINE — GOLDEN POPPIES — WERE EVERYWHERE.

AFTER A COUPLE OF HOURS THAT MORNING, I GOT TO WHERE THERE WAS NOT ONLY A BEACHSIDE LANDING STRIP, BUT TWO REALLY NICE CABINS BACK FROM THE BEACH ON A GRASSY MEADOW.

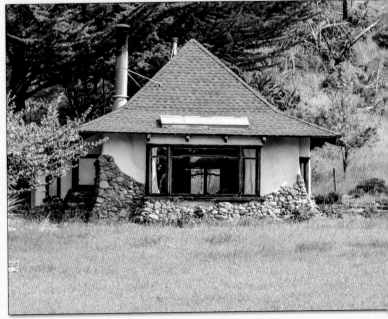

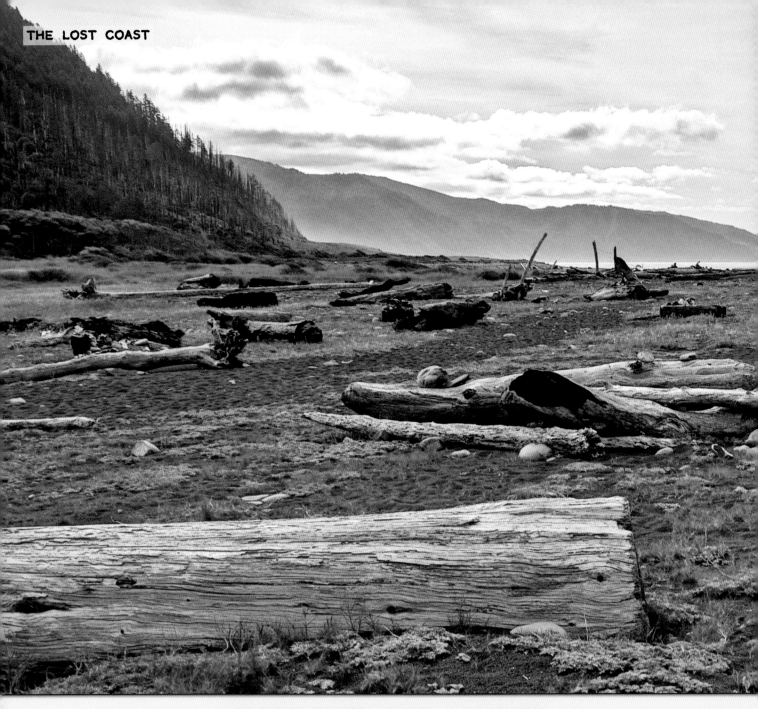

AFTER CROSSING THE CREEK, I CAME TO MILLER FLAT, WHERE
THERE WERE A LOT OF DRIFTWOOD AND LOW WINDBREAK
SHACKS BUILT BY HIKERS. UNLIKE AT JUST ABOUT ANY OTHER
SPOT ON THE NORTHERN CALIFORNIA COAST THAT I'VE VISITED,

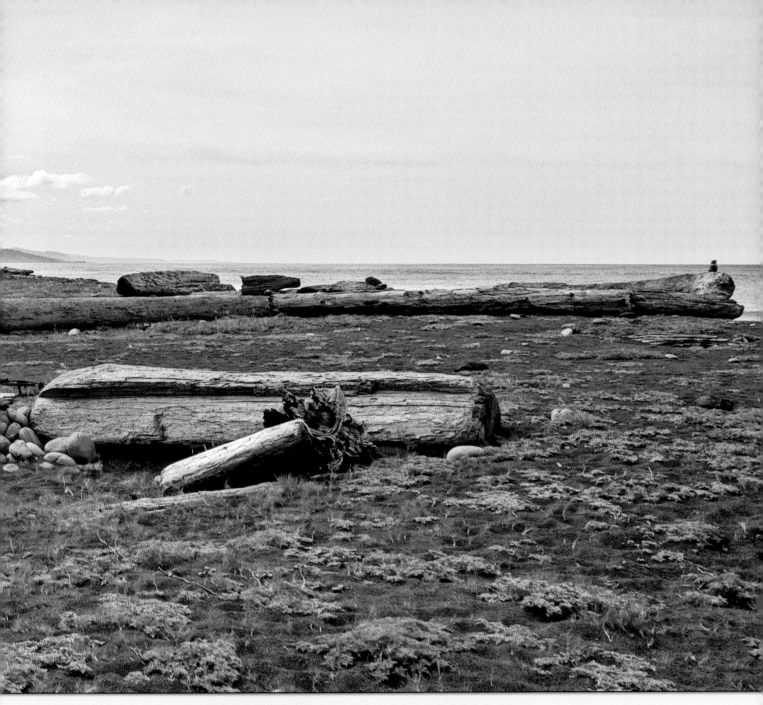

MOST OF THE DRIFTWOOD HERE IS REDWOOD. ON ANY OTHER
MORE ACCESSIBLE BEACHES, PEOPLE WILL FIGURE OUT A WAY
TO HAUL OFF REDWOOD LOGS. BUT HERE, THERE'S JUST NO
VIABLE WAY TO RETRIEVE THESE VALUABLE LOGS.

I'LL BET THIS REDWOOD LOG WAS 100' LONG.

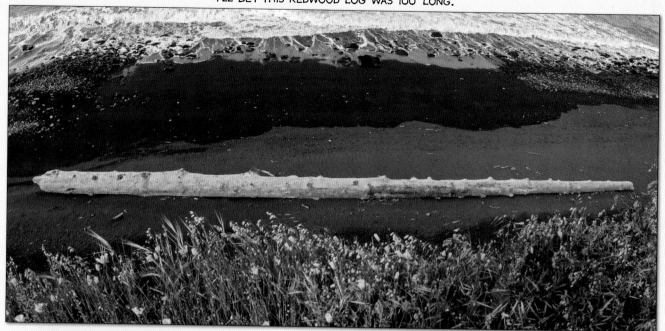

LEAP BEFORE YOU LOOK.

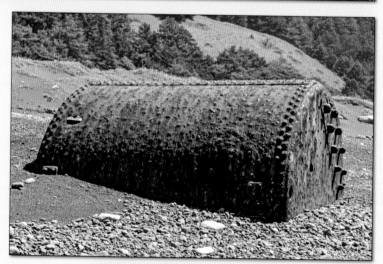

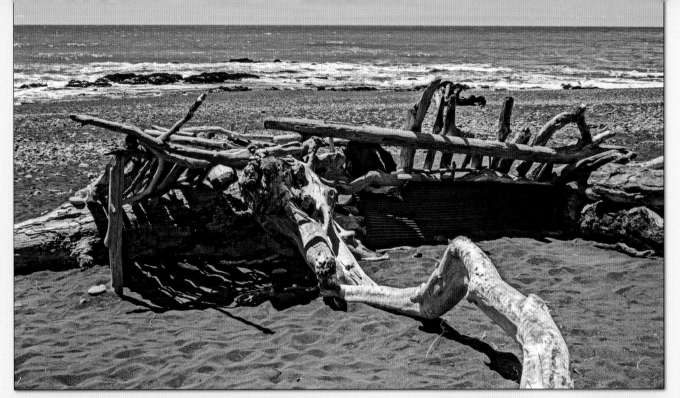

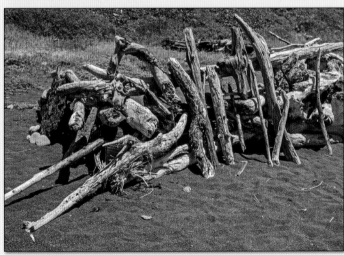

MY FINAL REST STOP ON THE THIRD DAY. I LAY IN
THE SHADE TO COOL DOWN AND RECHARGE.

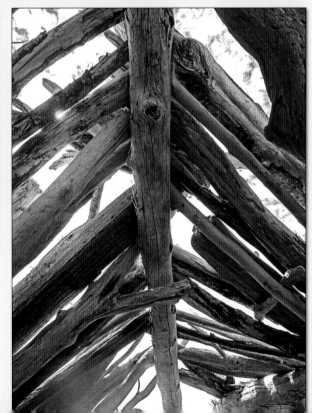

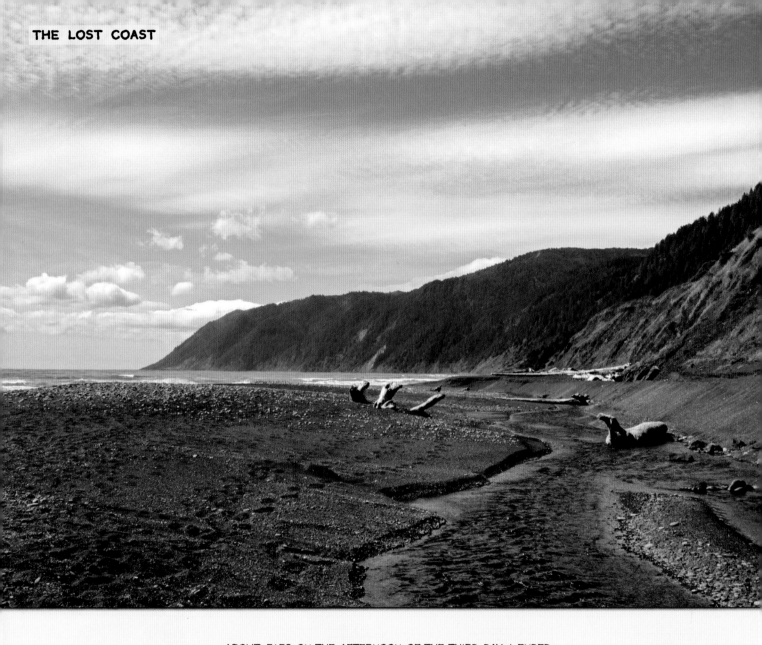

ABOUT 3:30 ON THE AFTERNOON OF THE THIRD DAY, I ENDED
UP WALKING ON SANDY BEACHES. THIS IS LOOKING NORTH,
BACK FROM THE DIRECTION I'D COME — ABOUT 8 HOURS
HIKING THAT DAY.

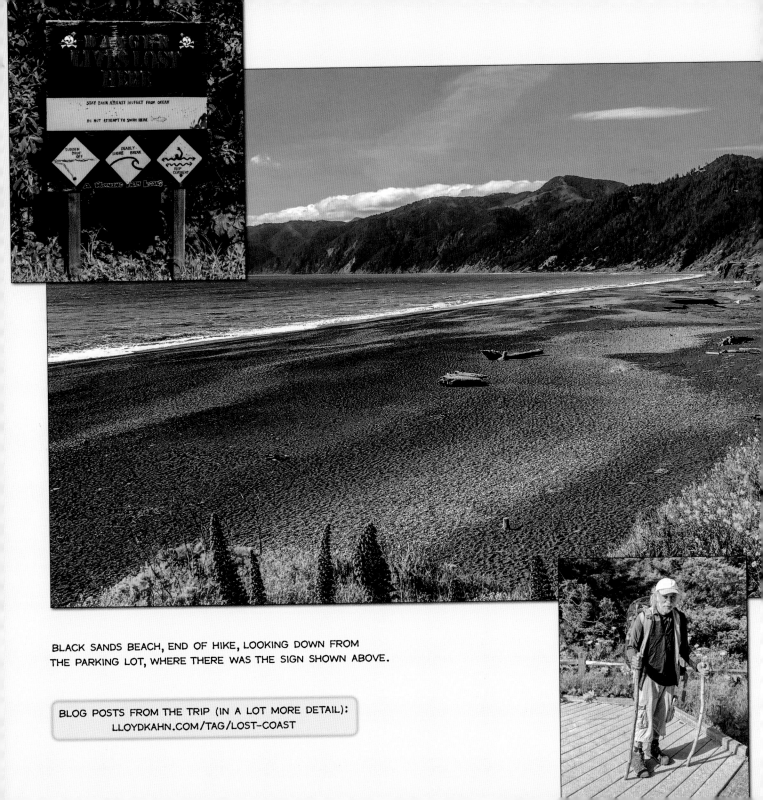

BLACK SANDS BEACH, END OF HIKE, LOOKING DOWN FROM
THE PARKING LOT, WHERE THERE WAS THE SIGN SHOWN ABOVE.

BLOG POSTS FROM THE TRIP (IN A LOT MORE DETAIL):
LLOYDKAHN.COM/TAG/LOST-COAST

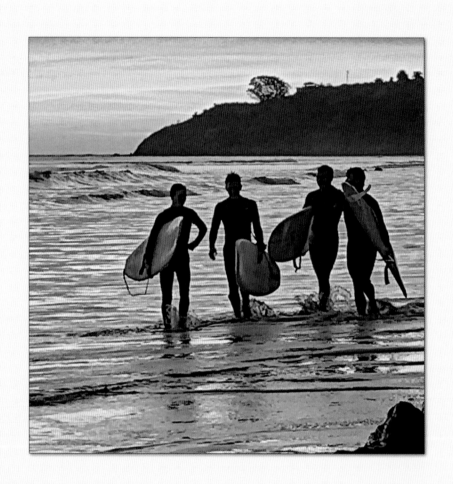

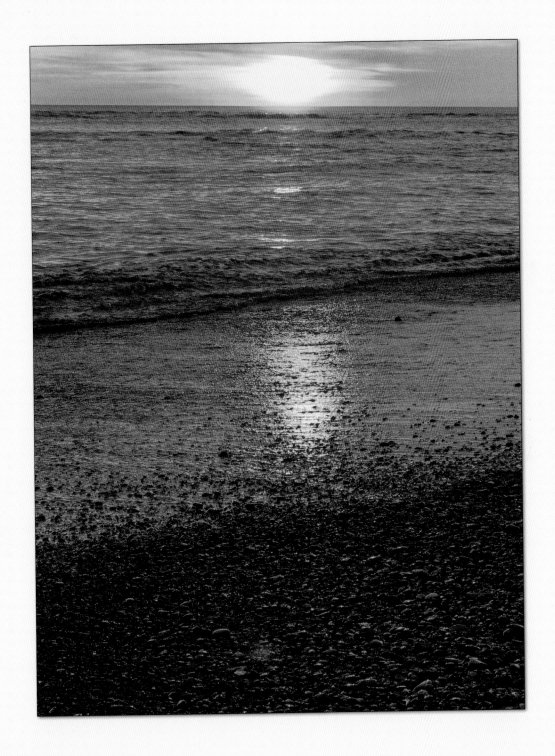

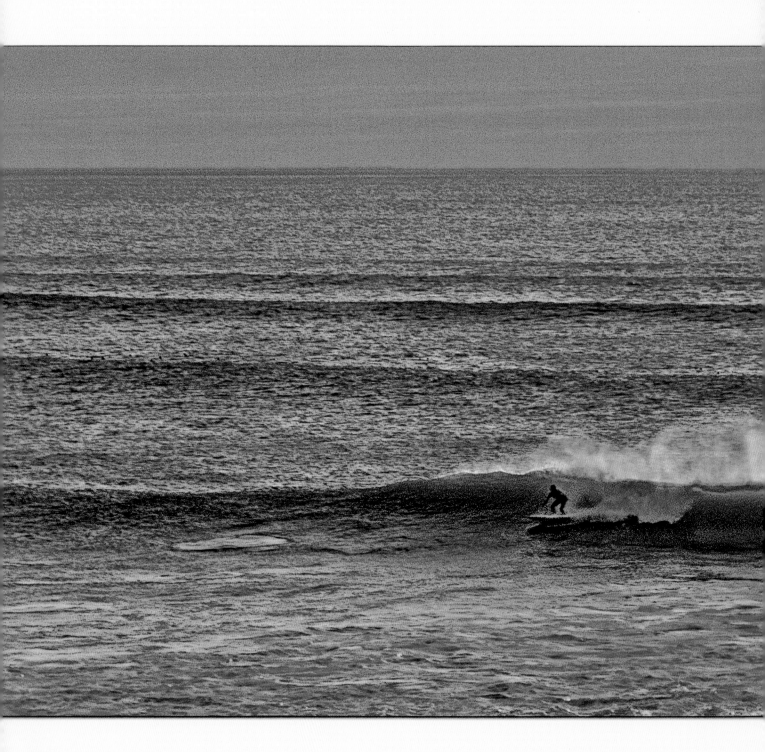

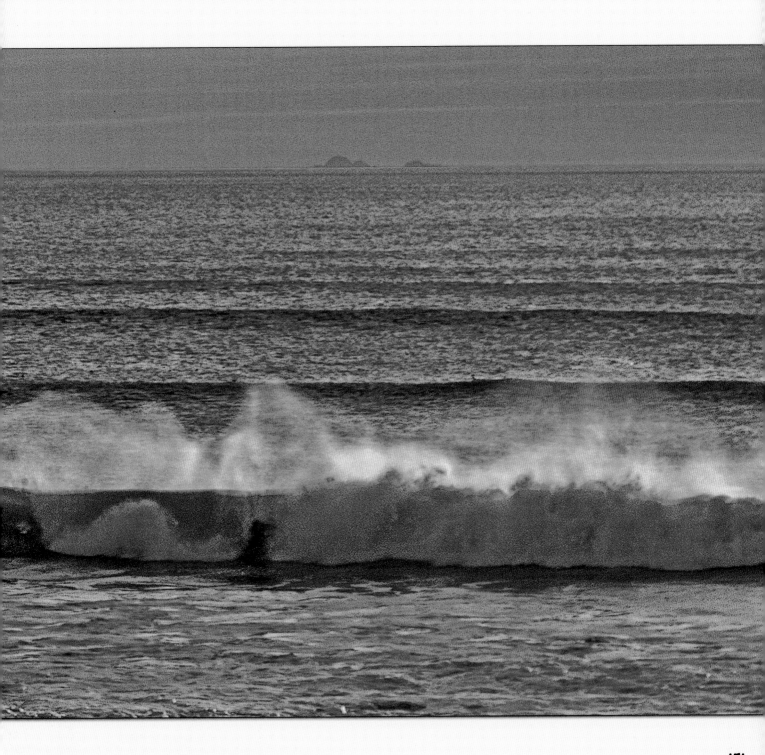

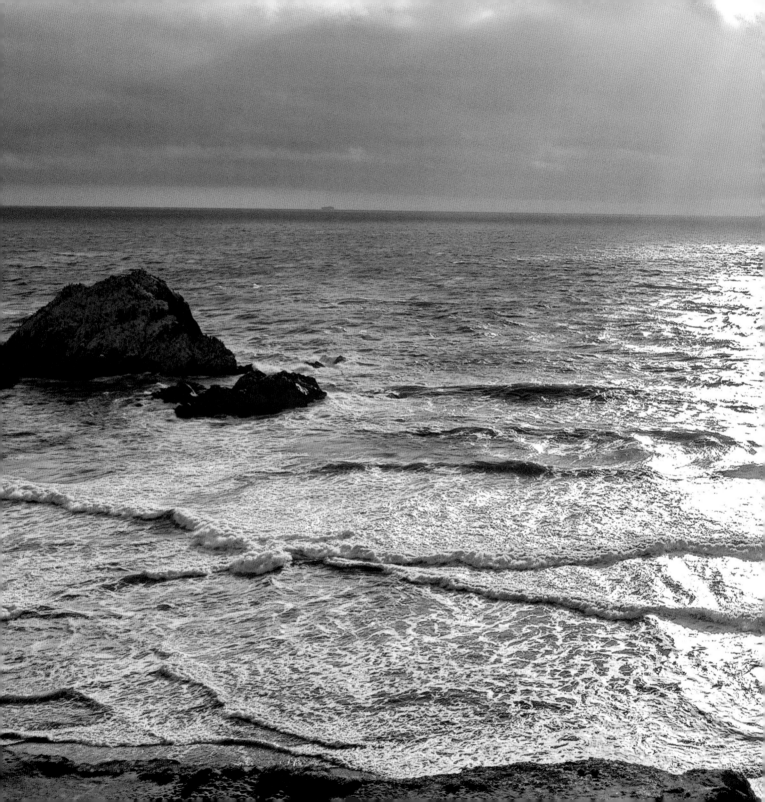

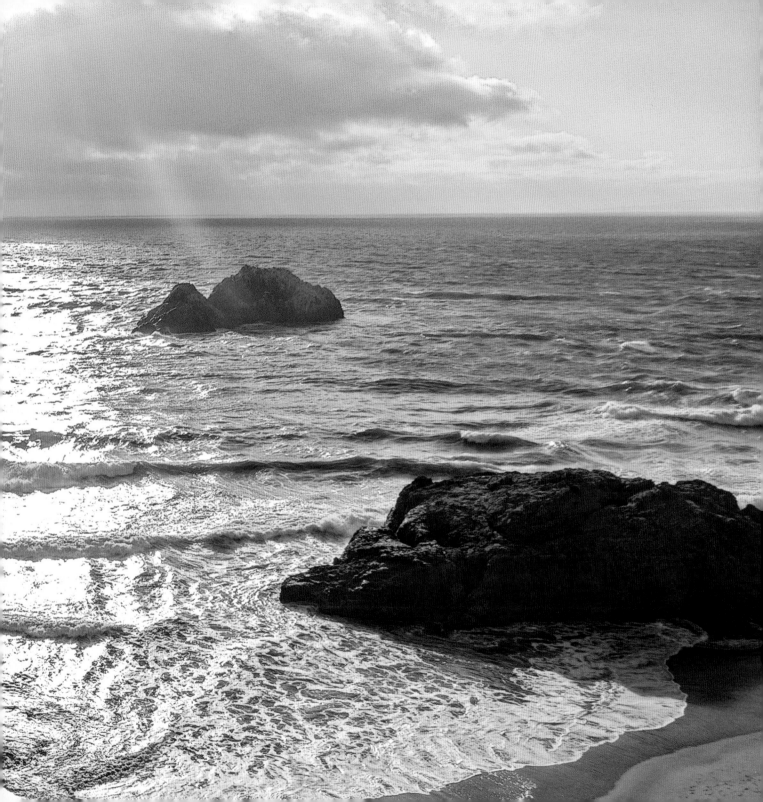

I FELL IN LOVE WITH THE OCEAN WHEN I WAS 17 YEARS OLD. I GREW UP IN
SAN FRANCISCO AND WAS ON THE LOWELL HIGH SCHOOL SWIMMING TEAM.
OUR MEETS WERE OUT AT THE HUGE FLEISHHACKER POOL* AT OCEAN BEACH.

AFTER A MEET IN SPRING, 1952, JIM FISHER, A POWERFUL SWIMMER
(WHO WENT ON TO BECOME A LEGENDARY BIG WAVE SURFER IN HAWAII)
AND I WALKED ACROSS THE GREAT HIGHWAY AND JIM LED ME OUT INTO THE
OCEAN. I'D NEVER BEEN OUT PAST THE WAVES BEFORE AND I WAS STUNNED
BY THE BLUE WATER AND THE BLUE SKY AND THE SWELLS, WHICH BOBBED
US UP AND DOWN. BEAUTIFUL!

FROM THAT DAY ON, I STARTED HANGING OUT AT THE BEACH AND
EVENTUALLY STARTED BODY SURFING AT KELLY'S COVE (NEXT TO THE CLIFF
HOUSE), WITH A BUNCH OF OTHER GUYS — ONE OF WHOM WAS JACK
O'NEILL. THERE WERE NO WET SUITS THEN, AND WATER WAS OFTEN IN THE
LOW 50s, SO WE USUALLY BUILT A FIRE BEFORE GOING OUT SO WE COULD
WARM UP WHEN WE CAME BACK IN.

✱ ✱ ✱

A COUPLE OF YEARS LATER, I GOT MY FIRST RIDE ON A SURFBOARD AT THE
MALIBU COLONY. I WAS SO STOKED THAT WHEN I GOT BACK TO STANFORD,
I STARTED GOING TO SANTA CRUZ EVERY CHANCE I GOT.

I CHANGED MY MAJOR TO ECONOMICS BECAUSE THERE WERE NO FRIDAY
CLASSES AND I COULD LEAVE FOR SANTA CRUZ EVERY THURSDAY AT NOON.
I LOVED SURFING, I LOVED THE BEACH, AND SINCE THEN, I'VE BEEN IN THE
WATER OR ON THE BEACH WHENEVER POSSIBLE.

MY FIRST FULL-LENGTH WETSUIT,
KELLY'S COVE, SAN FRANCISCO, 1960

*IT WAS 1,000 FEET LONG, AND THE LIFEGUARDS PATROLLED IN ROWBOATS.

PHOTOS AND LAYOUT: LLOYD KAHN
PRODUCTION BY RICK GORDON
EDITING: LESLEY CREED
FONTS: ARTHUR OKAMURA
PRINTING COORDINATOR: TREVOR SHIH

THESE PHOTOS WERE SHOT WITH A VARIETY OF CAMERAS:
OLYMPUS STYLUS 1200, OLYMPUS OM-D E-MI; SONY CYBERSHOT RX100;
CANON 20D, CANON POWERSHOT S-90, CANON POWERSHOT S-95,
CANON POWERSHOT S-100; IPHONE 5, IPHONE 6S, IPHONE 8S.

THANKS TO JENNIFER GATELY AND THE BOLINAS MUSEUM FOR
HOSTING AN EXHIBIT OF MY PHOTOS OF DRIFTWOOD SHACKS THERE
IN 2016 — WHICH LED TO THIS BOOK. THANKS ALSO TO ELISE CANNON
OF PUBLISHERS GROUP WEST FOR ENCOURAGING ME TO MAKE THE
BOOK AVAILABLE TO BOOKSTORES, WHICH LED ME TO EXPAND AND
REVISE AN EARLIER DIGITAL PRINTING INTENDED JUST FOR FRIENDS.

THANKS TO PGW FOLKS, GRAHAM FIDLER, BILL GETZ, ERIC GREEN,
KEVIN VOTEL, AND KIM WYLIE FOR FEEDBACK ON THE BOOK.

FINALLY, THANKS TO MY BEACHCOMBING PAL, LOUIE FRAZIER.

FOR A COMPLETE LIST OF SHELTER BOOKS,
GO TO WWW.SHELTERPUB.COM

SHELTER PUBLICATIONS, INC.
BOLINAS, CALIFORNIA, USA

LLOYD'S BLOG: LLOYDKAHN.COM
INSTAGRAM.COM/LLOYD.KAHN
TWITTER.COM/LLOYDKAHN
THESHELTERBLOG.COM

THE SHELTER LIBRARY OF BUILDING BOOKS

SHELTER (1973)

SHELTER II (1978)

HOME WORK (2004)

BUILDERS OF THE
PACIFIC COAST (2008)

TINY HOMES (2012)

TINY HOMES ON
THE MOVE (2014)

SMALL HOMES (2017)

FROM 1973–2017
7 BOOKS — OVER 7,000 PHOTOS
OWNER-BUILT HOMES

30% OFF ON 2 OR MORE BOOKS
PLUS FREE SHIPPING

60% OFF ON ALL 7 BOOKS
PLUS $10 SHIPPING (IN USA)

WE WANT TO GET OUR BOOKS OUT THERE!

SEE THE BOOKS AT:
WWW.SHELTERPUB.COM

SHELTER PUBLICATIONS, INC.
BOLINAS, CALIFORNIA

WWW.THESHELTERBLOG.COM
INSTAGRAM.COM/SHELTERPUB
LLOYD'S BLOG: LLOYDKAHN.COM
INSTAGRAM.COM/LLOYD.KAHN